THOMAS "DETOUR" EVANS

BE THE ARTIST

THE INTERACTIVE GUIDE TO A LASTING ART CAREER

Text © 2020 **Thomas "Detour" Evans**

Illustrations by Thomas "Detour" Evans (pp. 43, 77, 115, 125, 127, 143, 191); Kateri Kramer (pp. 7, 19, 27, 50, 96, 135, 145, 203, 205, 213); Adobe Stock Images: (pp. 34, 62, 86, 100, 192)
Photography courtesy of Adobe Stock Images (pp. 46, 56, 78, 94, 116, 140, 166, 172, 186, 200, 208, 226)

Library of Congress Cataloging-in-Publication Data on file.
ISBN: 978-1682752487

Printed in the United States of America.
0 9 8 7 6 5 4 3 2 1

Fulcrum Publishing
3970 Youngfield Street
Wheat Ridge, Colorado 80033
(800) 992-2908 • (303) 277-1623
https://fulcrum.bookstore.ipgbook.com/

CONTENTS

So what's the deal?

THIS BOOK IS ABOUT THE NUANCES OF NAVIGATING THE ART WORLD — NOT TECHNIQUE.

READ EVERYTHING. I WROTE THIS BOOK TO BE BOTH PRACTICAL AND EASILY DIGESTIBLE.

GOOGLE EVERYTHING AND EVERYONE MENTIONED.

ANSWER ALL THE QUESTIONS — THEY ARE THERE FOR A REASON.

TAKE NOTES, DOODLE, HIGHLIGHT SECTIONS, AND MARK UP AS NEEDED.

I CATER TO VISUAL ARTISTS, BUT ALL ARTISTS CAN GAIN INSIGHT FROM THIS BOOK.

DISCUSS THESE TOPICS WITH FELLOW ARTISTS.

THERE ARE NO RULES, SO HAVE FUN!

A NOTE FROM THE AUTHOR

This book was born out of my constant desire to help others. As my artistic career has grown, I have been asked more and more often about exposure, pricing, galleries, relationship building, street art, copyrights, and everything else under the sun. Eventually, I created a series of Instagram posts called "Art Tip Tuesday," where I share insightful information that artists around the world want to hear. Over the years, this effort has showed me that there is a need for a physical resource that artists can carry with them in and out of the studio, a resource that they can write in and make their own.

If you're looking for information on how to paint, sculpt, create interactive art, sing, or improve any other technique, this book is not for you. There are a slew of other books that address these topics. This book is all about the *who, what, when, where,* and *why* of establishing a solid foundation for a creative career. Although it focuses on visual arts, I intend for it to be inclusive of the entire creative community. As a matter of fact, many sections are just good life lessons in general. I want any creative to be able to learn from the lessons that I've acquired thus far.

It's short and sweet: I wrote *Be the Artist* to be easily digestible for anyone who wants timely and practical information. I've dedicated the left side of each spread to text and the right side to resources for you to research and space where you can take notes and doodle. I've not only included explanations from my experiences and point of view, but I have also included short anecdotes, interview responses, and resources that will help you internalize this information and put it into practice.

Read everything! I made each section short so that you won't feel like you're in a classroom being lectured. I encourage you to do one section a day so you can research all the phrases and terms in the "Your Googles" area. Rather than providing hard links that might fail over time, I've given you specific phrases that you can Google to find up-to-date information. This will also help you get into the habit of learning how to do independent research the aspiring artist way.

Last but not least, I've added questions to help you to stop and think about how each section applies to you. Be sure to take time to answer them all. Spend time exploring the content and media I reference in the Added Resources section as well. By the time you reach the end, this book should be unrecognizable from all the highlighting and markups you've added. Use it as a tool and a reference as you start to build your artistic practice.

BE
THE
ARTIST

YOU WANT TO BE
YOU WANT TO MEET
YOU ADMIRE
YOU WANT TO DIE AS
PEOPLE RESPECT
WHO MAKES AN IMPACT
WHO CHANGES THE WORLD
WHO INSPIRES

"EVERY CHILD IS AN ARTIST.
THE PROBLEM IS HOW TO REMAIN
AN ARTIST ONCE HE GROWS UP."

PABLO PICASSO

FOLLOWING YOUR PASSION

When people see my work, one of the first things they say is that I have a natural talent, or a gift, when it comes to art. This notion is profoundly false. As kids, we all are imaginative. We all create works with crayons and paints, and use any material we can get our hands on. I just never stopped. Like Pablo Picasso said, "Every child is an artist. The problem is how to remain an artist once he grows up." I passed on parties, prom, and many other activities just to create art, and I never regretted any of those decisions. That's how much I love to create.

Your passion must be something you love to do in any situation. It should be something that you spend your free time on whenever possible because it excites and compels you.

There are many different passions, such as making people laugh, helping others in need, or inventing ideas and concepts. You might execute your passions in a thousand different ways. My passion is creating visual works that I consider new. I accomplish this through interactive art, paintings, sculptures, and video. While these are all different media, they all accomplish the same goal. I also tend to lean heavily on the techniques that I do best: painting and making interactive art.

To help understand what drives you to a particular activity, try using an interview technique called *laddering*. Laddering peels away the layers of your actions to get to the subconscious motivations of why you do what you do. In its simplest form, laddering repeatedly asks the question, "Why is that important?" until you reach your core values. This activity will help you clarify decisions you need to make as you navigate the creative world.

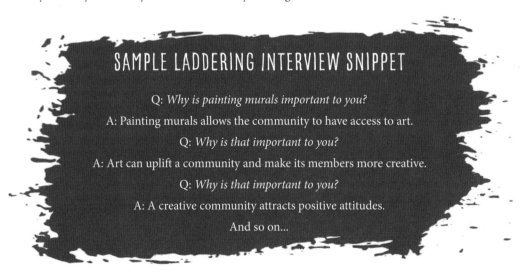

SAMPLE LADDERING INTERVIEW SNIPPET

Q: *Why is painting murals important to you?*
A: Painting murals allows the community to have access to art.
Q: *Why is that important to you?*
A: Art can uplift a community and make its members more creative.
Q: *Why is that important to you?*
A: A creative community attracts positive attitudes.
And so on...

HOMEWORK

List some activities you are truly passionate about. Do they make you happy and excited to engage in? Do they keep you up at night because you can't stop thinking about them?

Conduct a laddering interview on the activities you just listed. Continue asking yourself "why?" to uncover why those activities are important to you.

Write down several individuals who you admire. Conduct a laddering interview on each one to figure out why these people resonate with you.

Name some of the life goals and core values that you live by and why they are important to you. (Career, health, family, etc.)

FINDING MY CALLING

It wasn't until I was twenty-nine and halfway across the world that I decided that art had to come first in my life. Before, it was always the side dish rather than the main dish. During my academic career, I pursued a business marketing degree while also working in events promotion and at several nonprofit organizations. All the while, I painted during the nights, putting together group shows and some small solo shows at sneaker shops.

After graduating, I decided to work in advertising, but it was a clear mistake. Client projects were more about meeting numbers than being creative and daring. I soon left when I realized that all I could think about was making art after the workday. I then thought I would try to join the military like my father, but I tore my knee in jujitsu class during the application process. It ended up being a real blessing in disguise, but at the time it was depressing. I didn't know what the future looked like for me.

I continued painting and creating art while I looked for guidance. Then, in 2014, I happened upon an opportunity to volunteer in Tanzania. This was a no-brainer. If I didn't take the opportunity then, I likely wouldn't have another chance. I got my passport and hopped on a plane to Arusha, Tanzania. While there, I had few distractions or materialistic items. I spent much of my time teaching and providing support at a small school in a village called Orkeeswa. Being in a place that made life simple forced me to move past my fear of failure, and I was able to find out what made me truly happy. I even created one of my first murals there.

After returning to Colorado, I decided to give myself a year to see what I could achieve with my art. I had an amazing support system and artist community around me. The city of Denver was growing and there were plenty of newly constructed walls that needed art. It was a great time for me to take that leap. That said, the first six months were extremely rough. Since I didn't attend art school, I had to learn about the foundations of art and how to be a full-time artist. What should I have on my website? How should I approach galleries? What do I add to my artist resume? How do I stretch a canvas? So many things were new to me. After the eighth month, I started to pick up steam, with more opportunities coming into the studio and more work going out into collectors' houses.

I knew creating art was my calling because I wanted to learn everything. It was something I loved, it brought in income, and it was something I was good at. I soaked up as much knowledge as I could, trying to improve my practice by learning new techniques and processes. I regularly woke up at 4:00 a.m. to get to the studio and would leave around 11:00 p.m., repeating the same routine day after day. It didn't feel like work to me, and it still doesn't. I do have rough days, don't get me wrong. But I love that I have the opportunity to bring ideas to life.

"I was in college at the time, in 2011. I realized, once I couldn't keep my focus on the academics and all my energy and time was invested in dance, I knew that's where my time needed to go. Especially after having a conversation with my mother and remembering her saying to me, 'You know, Sweetie, college is always gonna be there. You can go back when you're in your fifties. But dance doesn't have a long time like that, so if you're gonna do something, do it one hundred percent.' It was that saying that truly got me laser-focused on really taking the leap and honing into what I do now. ... I haven't had any regrets since. Granted, doing this is the same as achieving greatness. This shit takes work, a lot of it, too. There is no shortcut to achieving your dreams. And more so, keeping those dreams and making them reality."

Jade Zuberi, dancer, photographer, cinematographer

TAKING THE LEAP

There's something inherently special about taking the leap and going at it full-time. Risking it all. You go from weekend warrior to battling every day for creative excellence. When I tell someone I'm a full-time artist, especially if they have a 9–5 job, they get excited and say they're proud that I took the leap. People just see you differently. They follow on social media to see the latest mural or installation I'm creating that week or which big brand I'm working with this month. There's a feeling that can't be duplicated when you make a decision to live without a safety net. Leaping from one job to another is scary, especially when the new job relies solely on your creativity to generate income, opportunity, and security. No book can give you a magic number on when to do this because everyone's situation is different. What you can do is inform yourself about hurdles you're likely to encounter and ways to navigate them.

AREAS TO THINK ABOUT

ACCOUNTABILITY

Understand that, as an artist, you need to hold yourself accountable for all aspects of your practice. Nobody is going to hold your hand in a meeting with a client or tell you that you're about to miss a shipping deadline for an important exhibit. You are the only individual that you can blame – no one else! You have to account for all aspects of your practice. Be aware that you will need to set routines, habits, and standards that you must adhere to.

BUILD A ROUTINE AND A SCHEDULE

Buy a yearly planner to set daily tasks and duties. Because this is work, establish work hours for studio practice and stick to them religiously. Why? Because doing so will give you a structure to work with and help you set boundaries and eliminate distractions. This will be an ongoing struggle because your schedule will likely change based on the project you're working on, but keeping this in mind can make the difference between accomplishing tasks in a timely manner and having to pull all-nighters to finish work.

MOMENTUM

Like moving a boulder, the hardest part is getting started. Know that when you start, it will take months, even years to generate enough momentum to feel comfortable. Even once you have that forward motion, it takes a significant amount of time and energy to keep it – because if it's lost, you have to work just as hard to gain it back. Think of an actor famous in the 1980s trying to make a comeback today. Use any tailwind you can to keep your momentum going. It's tempting to think that every artist can achieve success early in her or his career, but understand that success is different for everyone.

QUESTIONS TO ASK YOURSELF

Is there a large enough market for my work in my area? If not, where can I go?

Do I have consistent income from art opportunities to replace my current income?

Do I have existing collectors that are loyal to my work?

Do I have a support system in place to help guide me in my transition?

What will serve as my studio and what are my official studio work hours?

How will I keep track of my schedule?

How often will I do regular status checkups on my progress? (Weekly, monthly, etc....)

Am I located in a supportive arts community?

How much money will I need to save first to cover all my living expenses for a year?

Where will I get health insurance if I quit my job? Is Medicaid an option?

Will I do my own accounting or hire an accountant?

Do I want to register my art practice as a business?

What responsibilities do I have that will be affected by my transition?

Who will be affected by my success or failure?

EMPLOYER BENEFITS

There's a lot of comfort in being a full-time employee with benefits. As a full-time artist, there's little to no safety net. You have no sick days, no time off, no maternity or paternity leave. You have to arrange how you will handle the emergencies that pop up and the retirement plans that you need. This very reason is why many creatives still keep a job.

This will be different for every artist, so you have to examine your own situation. Look up ways to provide yourself some of the perks that a regular employer would have offered. Vacation time and health insurance are particularly important. Luckily, there are many companies and resources that can help creatives find solutions to a lack of employer-sponsored benefits. I talked to a financial planner and several insurance companies to find the best solution for my practice.

MULTITASKING

Similar to a small startup, you will have to wear many hats to sustain your practice. The marketing, accounting, scheduling, legal, project management, shipping, and other duties fall squarely on you. Before taking the leap, address how you are going to go about fulfilling all of these duties. You can do them yourself, enlist reliable friends and family, or outsource them to a credible professional.

FINANCES

Unless you're Jeff Bezos, you will need a sound financial plan. Organize your practice around the understanding of how cash actually flows in and out. Be aware that checks don't come on time and most businesses have a net-30 policy for paying vendors or contractors. That means that it takes 30 days after completion of the work for you to receive payment. I often don't have an exact date for when I'll get paid for a given project. Your monthly income will definitely fluctuate, so learning how to navigate inconsistent cash flow is crucial to your success.

SO WHAT'S THE SOLUTION?

When you finally decide to take the leap to become an artist, start your journey by not quitting your day job. It's better to figure out how to go independent slowly while you have the safety net of a reliable income. I spent eight years in Denver creating art before and after my regular 9–5 job. I participated in numerous art events and group shows to gain exposure. I was able to build a following, refine my voice, and learn about my collector base while still attending university. Put simply, you should already be pursuing your creative endeavors well before you decide to take the leap. This is the time when you build up skills and work on smoothing out your learning curve. Many artists, like muralist Sandra Fettingis, only make the leap once the opportunities they are receiving become too much to handle with a second job.

YOUR GOOGLES

- Insurance for artists
- Temporary disability insurance
- Accident insurance
- Retirement plan for artists

QUESTIONS TO ASK YOURSELF

How will I deal with taxes?

Which five people in my community can I turn to for mentorship?

What do my collectors look like, sound like, think like, and how can I meet more of them?

Will I have a home studio, or will I need to rent a studio?

How will I generate studio visits and other opportunities for people to see my work?

Which social media platforms are best for my work?

How will I save for emergencies and retirement?

Is there an "insurance for artists" that I can get?

How can I make my presence as an artist in the public unique?

"I had always worked a part-time job. So, I was last at the MCA (Museum of Contemporary Art Denver) and had been getting more and more work, and it just became harder and harder to manage everything. It was like, day job, art world, and personal life... it was really hard. Plus, I had been wanting to make the leap. I was scared. It really took me about six months to a year. I was talking to my friends about it constantly and they were like 'Just do it!' So I had enough projects lined up to where I was like, 'Okay, I'm going to do it,' and it was clear at the MCA that I needed to go. So I made the transition and it was really smooth."

Sandra Fettingis, mural artist and designer

ART AND KIDS

PARENTING DUTY CALLS

You can pursue your dreams, but you can't stop life from happening. You have to take care of your normal responsibilities too, which, if you're a parent, are numerous. Not too long ago, artists, particularly female artists, were told that having a family and kids will stifle your career and artistic growth. Nowadays, audiences are just as interested in the artist's life as they are the art itself. It can even be beneficial to share parts of your parenting life.

Having children adds responsibilities and shifts your priorities. Time and resources are split. Living with no health insurance is not an option. After having several conversations with artists who are also parents, there seems to be a consensus that your arts practice will adjust. How it does so will depend on your situation: relationships, financials, family, and practice. There's no one-size-fits-all solution to this topic. However, there are a few areas that many artists highlighted:

SUPPORT SYSTEMS

The first line of support is a significant other who truly understands your artistic practice and how important it is to your well-being. The compromises and concessions that have to be made as a full-time artist can take a toll on relationships, from financials and scheduling to intimacy and other resources. Having a partner, or other family and friends, who will be supportive through good times and bad is key.

INCREMENTAL IMPROVEMENTS THROUGH SCHEDULING

Just because your practice may be scaled back by parental responsibilities doesn't mean that you can't set aside dedicated time to it. UK artist and mom Rachael Francis sets aside thirty minutes each day to chip away at her projects. Sometimes carving out a small portion of time every day is all you need to keep the momentum going.

STUDIO INTEGRATION

Many artist talked about bringing their children into their practice. Denver artist and dad Patrick Kane McGregor exposed his son to his creative world, and now the two are a tag-team duo who paint murals together across the United States.

IT GETS EASIER

As your children grow and become more independent, you'll be able to put more time back into your practice.

"Structure and consistency have helped us tremendously, both when our kids were much younger as well as now. We make sure to consistently evaluate our family priorities and integrate our creative priorities into them. We have always involved our children in the arts, and encouraged them in their own artistic pursuits. Finding the time to be creative is a bit more challenging with kids, so we constantly allowed them to sing if we were singing, write if we were writing, and play instruments with us. We now have a daughter who is a visual artist/bass player/poet/vocalist, a daughter who is a chef/fiber artist/paper crafter/piano/trumpet player, and a son who is fashion designer/vocalist/jewelry designer/drummer.

Aja and Samir (The Reminders), musicians

I am blessed to be able to work with my wife. She handles the business side of things – accounting, contracts, website, online store, etc. – which frees me up to fully concentrate on the creative end. We have structured days: me working 9 to 6, and then family dinners every night. We spend time with the kids, and then when they are in bed, my wife and I catch up, work a bit together. I call it co-playing, her on a laptop and me in my sketchbook. We can talk about anything during these times. I can't lie, I love her company so much, even after the twenty-plus years we've been together. Thank God for my wife; she's been the rudder steering this ship and keeps me sane.

Greg "Craola" Simkins, artist

MENTORS

Having a mentor, or multiple mentors, is always advised. Mentors bring the kind of valuable knowledge and expertise to the table that simply can't be bought or read in a book. They can provide you with a wealth of information and insight that could drastically reduce the learning curve associated with your growth as an emerging artist.

BENEFITS OF HAVING A MENTOR

- Informs you on how to capitalize on strengths and reduce your weaknesses
- Offers encouragement during times of difficulties
- Sets reasonable benchmarks for you to achieve
- Prevents you from pursuing bad ideas and making bad decisions
- Expands your network and introduces you to new opportunities

Good mentors are not always the most experienced people. Rather, good mentors are like teachers – they dedicate some of their time to help foster the next generation of practitioners in their field. The mentor you choose should love having a mentee to share their knowledge with. They should exude enthusiasm in the field and promote continued growth. They should also have a communication style that motivates change. This is especially important because a mentor must be able to provide honest feedback and criticism.

A good mentor relationship will feel like your mentor is like a big brother or sister willing to show you the ropes. You should get the feeling that they want you to succeed not only in their given field, but in life in general. It's an ongoing relationship, so as your mentor grows and gains more knowledge, you grow and gain more knowledge as well. Whomever you decide to approach as a mentor, understand that this is a long-term commitment, so having a good fit is extremely important.

THE ASK

- Start the initial conversation by requesting an in-person meeting
- Clearly describe your goals for the relationship
- Clearly indicate that you see this relationship as long term and will put in the work to make measurable progress
- Communicate a reasonable schedule that respects the mentor's time

HOMEWORK

Write down five potential mentors. You can find potential mentors by looking in creative communities in your local area.

Write down goals you want to achieve with your mentor's guidance.

How often are you planning to meet with your mentor?

Are they in a position you seek to achieve?

Do you have an existing relationship with them?

Are they able to make a long-term commitment to the relationship?

Do they live close to you, and are they able to communicate regularly?

Are they able to be critically honest about your work and progress?

FEAR OF FAILURE

The fear of failure is extremely profound and is something you have to tackle before you start your career. Often, people give in to their fears before they even begin and become too paralyzed to take action. Even after taking the leap, fear never fully goes away. In fact, fear will always be present to some degree. Even the most successful artists fear losing their momentum and falling out of favor with their audiences. Suffice it to say that you will routinely be dealing with some level of fear, especially as you are confronted with rejection and disappointment.

You will never fully get over this fear of failure, but rest assured that it becomes smaller and less relevant as you progress in your journey. It's all about approaching the fear head-on and embracing the fight for success. Identify goals you wish to accomplish. Break those goals into realistic and manageable ones that can easily be achieved. For example, a bite-sized goal could be as simple as initiating contact with representatives of a gallery you wish to build a relationship with.

Sometimes the best way to begin the journey of tackling failure is to tag-team it with a peer. It's much easier to tackle the unknown when you have someone to lean on. Joining forces to take the leap can reduce anxiety and reassure you that you're not alone. It's scary to venture into uncharted territory, so get as much support as you can.

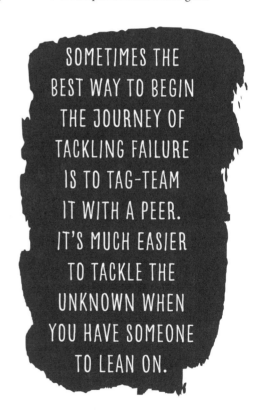

SOMETIMES THE BEST WAY TO BEGIN THE JOURNEY OF TACKLING FAILURE IS TO TAG-TEAM IT WITH A PEER. IT'S MUCH EASIER TO TACKLE THE UNKNOWN WHEN YOU HAVE SOMEONE TO LEAN ON.

Embrace failures and learn from them. It is important that you learn how to overcome failures so that the next time you are confronted with a similar situation, you are prepared to not only overcome it but excel in doing so. Build up your resistance to fear by tackling as many small tasks as possible. As you achieve small, incremental successes, little by little, you will be able to push fear aside and replace it with planning your next installation, experimenting with the new color in your palette, or having coffee with a new collector.

NOTES 'N' DOODLE

"There were so many times that I just wanted to quit and give up, but my showrunner, based out of LA, continued to talk me off the ledge and remind me that I was very talented and I needed to continue to grow and excel in this career, so I didn't. Within two weeks of leaving Love and Hip-Hop, I got my first associate producer job for MTV. But as a freelance producer, you can sometimes go several months without a gig, and things would get very hard for me financially. There were two occasions when I completely decided I was going to quit producing and go work at a restaurant. It felt like that was a better route for me because there is more consistency. On both of those occasions, I got a call from a production company the very next day, which always reminds me that I needed to stay true to my path."

Jai Harris, television producer, MTV/VH1

MENTAL HEALTH FOR ARTISTS

DOUBTING YOURSELF

At the root of fear is doubt. Doubt that you made the right decision. Doubt that you're good enough to show your work alongside others. This doubt can eat at you both inside and outside the studio. Other people's opinions can drown out your own thoughts. This is especially true during those periods where things are not going right: when your work is not selling, when your art is being rejected, and when you feel like no one is listening.

Simple virtues of patience and trusting the process can pull you through these situations, letting you emerge stronger and more confident in yourself and your work. Trusting in decisions you made requires a genuine understanding that success does not happen overnight.

COMPARING YOURSELF

We do not all peak at the same time. We do not all begin our journey from the same starting line. We're not all going in the same direction. I say this to warn you not to compare yourself to others, because doing so will always lead to a misrepresentation of your current situation. That is especially true in our social media–driven age. You cannot afford to compare yourself to the career highlights of other people, because that's exactly what they are: highlights. Instead, focus on comparing yourself to the previous month's version of yourself. Evaluating your own progress over time is a better way to measure your growth and evolution as an artist.

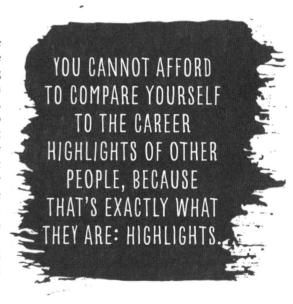

YOU CANNOT AFFORD TO COMPARE YOURSELF TO THE CAREER HIGHLIGHTS OF OTHER PEOPLE, BECAUSE THAT'S EXACTLY WHAT THEY ARE: HIGHLIGHTS.

NOTES 'N' DOODLE

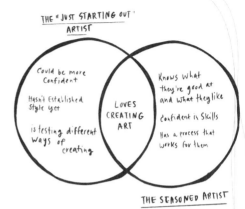

THE "JUST STARTING OUT"
ARTIST

Could be more
Confident

Hasn't Established
Style yet

Is testing different
Ways of
creating

LOVES
CREATING
ART

Knows what
they're good at
and what they like

Confident in Skills

Has a process that
works for them

THE SEASONED ARTIST

ISOLATION

Like a medical student in graduate school or an athlete training for the Olympics, to be great at something, you must dedicate a significant amount of time to improving your craft. This, however, puts many creatives on a schedule that conflicts with other people's regular routines, creating a potentially isolating environment. Lonely studio session after session can be draining, especially when you've run out of new episodes of your favorite Netflix series. Sometimes isolation can help you focus, but it can also be the enemy of creativity. Just being aware of this can help you consciously work on balancing life inside and outside your creative space. Schedule time outside of the studio with other creatives, or consider joining a group studio or other coworking space. For example, many cities have makerspaces where people share tools and work together on creative projects.

> WORK ON SCHEDULING TIME OUTSIDE OF THE STUDIO WITH OTHER CREATIVES.

COMPETITION AND ENVY

People often talk about the competitive and envious atmosphere of the professional art scene. "They only got in the gallery because they know this person and that person." The air is thick with judgment and disdain. I'll be honest: you'll definitely run into this environment. The art world is not immune to the worst of human nature. The goal is for you not to play into this mind-set. It's hard when you are constantly bombarded by other artists' successes on social media. You may feel that you deserve the same, if not more. Of course there are nepotism, favoritism, and biases, but guess what? Wallowing about it doesn't do shit for you or your practice. Your focus should be on creating your work and not comparing what you do or don't have to what others have. You might feel that you are in competition with every artist you see, but in reality, you are only in competition with the current version of yourself, trying to get better.

"I spend hours alone in my studio painting and working on projects, as most studio artists do. I don't necessarily define it as a negative situation for me. Besides a place for working, it is a place of sanctuary, allowing me to freely think and reflect on things. Having my computer and TV present also allows me to take in inspiring and thought-provoking documentaries and talks. But then, on the other hand, I frequently have to get out and socialize with friends and family, or visit other artists and occasionally open my studio for visits. I have future ideas and projects that will require collaboration with other creatives. That is something I look forward to, but meanwhile, taking the opportunity to get out and meet new people and share in what they are doing is inspiring and fulfilling."

Ronald Jackson, fine arts painter

"I think regret and insecurity are part of being an artist. I always think that I'm only as good as my last illustration, and then you see another artist killing it and you're like, 'Fuck, they're amazing.' And here you are doing your thing, and you're like, this sucks. I feel like I'm always trying to prove myself. I'm always trying to prove my worth. I'm always trying to up my last illustration. Just something in my character. Other artists might be different, but I'm always trying to prove myself, and that doubt is always there. It's always a part of what I do. Someone asked me about my solo show I'm planning, and I feel nothing but fear. But fear is not a negative thing. It can be positive. That fear is driving me to kick ass. It's driving me to make the best show I've done in my life. I just don't want to have a shitty show. So that fear of having a shitty show is driving me."

Juan "Joon" Alvarado, artist, illustrator

MENTALITY OF THE NEW ARTIST

This isn't your grandparents' art world. Rules have changed, or no longer apply. For better or worse, today's artists have to deal with those facts. A creative life demands you to be daring, risk-taking, and hard working. Moreover, today's successful artists are much more savvy and are taking their destiny into their own hands. Gone are the days of sitting in the studio hoping for a collector to find you, or for a gallery to pluck you out of art school. You have to be able to create demand for your work.

THE 12 COMMANDMENTS OF THE NEW ARTIST

1. YOU'RE 100% RESPONSIBLE

One of the mind-sets that I have always embraced is to take 100% responsibility for the results of any situation that I'm involved in. It's easy to blame others when things don't turn out the way you want them to, but when you take ownership of the results, even when decisions are out of your hands, you begin to work harder at strengthening your weaknesses and addressing blind spots in your practice.

A great example would be signing a bad contract because you failed to fully read it. You could easily lose rights to your work and be responsible for unforeseen expenses. Failing to read the contract is no one's fault but your own. In cases of not being accepted to a group show, I don't blame the curator, I only think about how I can improve my portfolio for the next group show. This thinking forces you to pay close attention only to the things that you have control over. From reading contracts and handling shipping, to installing exhibitions and working with other artists, the buck stops with you.

2. EMBRACE THE GRIND

Embracing the grind is all about appreciating all the obstacles, experiences, and challenges you will encounter during your journey. Being an artist is not an easy life to live. You are constantly working to create new ideas, all while overcoming multiple failures. Like strengthening a muscle that must be broken down to grow, the hardships you will encounter in your practice will challenge your creative problem-solving muscles, allowing you to consistently grow as an artist.

NOTES 'N' DOODLE

"I've always been fearless, so when it came time to do work,
no matter the scale, it was a matter of when and where."

Rob Hill, visual artist, fashion designer

"The grind should always be important, at least if you're doing what you love full-
time. If what you love is used as a hobby type of outlet rather than a career, then
do it when you feel. But if it's a career, or you're in pursuit of making what you love
into one, get into the rhythm of planning and scheduling, organizing your life."

Jade Zuberi, dancer, photographer, cinematographer

3. DON'T DOUBT YOURSELF AND JUST DO IT

You can't lose if you don't play. You also can't win if you don't play. As legendary hockey player Wayne Gretzky said, you miss 100% of the shots you don't take. I often hear artists tell me they didn't pursue an opportunity because they didn't believe they could get it. That type of thinking prevents you from reaching beyond your skill set and expanding your capabilities. I regularly apply for and take on opportunities that are well outside my comfort zone. Why? Because doing so forces me to adapt, grow, and learn. There's always an excuse you can use to sidestep opportunities you think are beyond your capabilities, but growing requires that you overcome challenges and try new things.

> I REGULARLY APPLY FOR AND TAKE ON OPPORTUNITIES THAT ARE WELL OUTSIDE MY COMFORT ZONE. WHY? BECAUSE DOING SO FORCES ME TO ADAPT, GROW, AND LEARN.

4. DON'T TAKE THINGS PERSONALLY

Regardless of the decisions others make about my work, my portfolio, my application, my interview, or about me, I don't take anything personally. Even if there is a sprinkling of truth to a decision being personal, I cannot, and will not, dwell on it. At some point in your career, you will eventually find yourself receiving pushback or flat-out rejection. When this happens, taking things personally only leads to wasted time and energy. You have to remember that there are 7 billion people on this earth and not every one will understand you and your work.

Furthermore, we often don't know all the reasons behind someone else's decisions. Jumping to conclusions can overlook the situation they are in, or intent they may have, when making that choice. Taking things personally when you don't have all the information only allows other people's actions to dictate your emotions. Don't let your personal feelings suck your time, energy, and mental space.

NOTES 'N' DOODLE

5. "NO" MEANS "NO"

Create boundaries in your practice. Learn that there are no projects that you can't say "no" to. It's much harder to do that as you're climbing the ladder in your journey, but when an obstacle disguised as an opportunity comes across your practice, you have to learn to say no. It's hard, I know. I've been in the same situation. Your friend, coworker, or family member comes to you asking you to create work that you are not excited about. You end up reluctantly saying yes to a project that eventually eats up your creative energy after you procrastinate for weeks. Now you're frustrated and resentful in the creative space you reserved for your work.

You may also receive requests to modify, add, or remove elements of a project that could affect the end results of your work. "Are you able to change this, this, and this?" Because taking on projects requires time and energy, you need to protect them like you protect everything else. Learning to say no will free up your practice for more desirable opportunities.

Saying no can be as easy as having some go-to responses that ease the rejection. "Unfortunately, I'm not taking on projects this year, but I have a friend that might be interested." "I would love to, but my time and resources are already stretched thin." "Unfortunately, if I made that change the composition will be thrown off." I'm sure you can think of other responses to politely turn down requests. I have found that always giving an alternative solution keeps your response from feeling like a rejection. "I can't do it, but I know someone who can." "I can't do 'A,' but I can do 'B' to fulfill that need." Learn to say no to protect your practice.

6. BE SO GOOD, THEY CAN'T IGNORE YOU

Regardless of who you are, you will come across obstacles and challenges you need to overcome, especially when working with people. To be so good they can't ignore you is to excel in your area to the point that your artistry can't be denied inclusion. Your work can overrule others' biases.

7. CREATE YOUR OWN OPPORTUNITIES

Opening your own doors will allow you the freedom to move throughout your career without limitations. Don't rely on gatekeepers for acceptance because you should be the one that dictates your journey. If they don't let you on the field to play, make your own.

"*The more nos you say, the higher the quality of your yeses become.*"

Joseph Martinez

"*I don't know anything really about being professional, or being a high earner. But if there's any advice I do have for people wanting to be freelance artists, it's this: The best thing you can do is say no when you need to say no, and be willing to walk away from a project if it's angling you in a direction you don't like. You'll be surprised how often the situation will fix itself after that. Money magically appears. Creative control comes back. And if neither show up, you at least have time to work on things the way you want without the resentment, even if you're eating ramen for a few. I'm not kidding though, most people respect you for respecting you, and you won't even end up on that ramen dinner so often.*"

Birdcap, muralist, illustrator, and professor

8. DON'T RELY ON PREVIOUS ACCOMPLISHMENTS

Relying on previous accomplishments is the enemy of evolving. This doesn't mean you need to disregard them; instead, use them as building blocks for further growth. Don't be afraid to venture outside of what got you in the door. Your initial accomplishment came from your creative explorations, so don't doubt that you can do it again. Your drive to get better and to expand your art should always be in perpetual motion.

9. CREATE YOUR OWN LANE

We are all here to create work that will add something new to the creative conversation. To make that happen, we cannot be a carbon copy of others. Whenever possible, use others' work as a foundation and then find ways to carve your own path. It's okay to bend and break the rules – think of them as a suggestion. Listen to that creative "yes" voice inside of you and then figure out how to make the idea happen. Your unique background and experiences will often lead you off the beaten path, and that's great.

10. IF YOU'RE ON TIME, YOU'RE LATE

Use your timeliness to go above and beyond people's expectations of professional creatives. Historically, artists have a reputation for being disorganized and unreliable. If you want others to take your career as seriously as you do, punctuality, documentation, execution, and a keen eye for detail are of utmost importance. When galleries, directors, and other decision makers are giving artist referrals to others, they are more likely to refer artists who have a reliable record for meeting deadlines.

11. FITFO (FIGURE IT THE FUCK OUT)

In the age of Google, there is no reason why you should be paralyzed by a lack of information. Much of what I have learned about how to navigate the art world came from actively seeking knowledge through websites, artist friends, community workshops, experimenting, and just plain doing. You're not going to have all the answers given to you in a neat little package, so learning how to seek the answers you need is what separates artists who grow consistently from those who don't. Learning how to dig for answers is a skill, and when you get good at it, you'll find yourself capable of taking on projects far beyond your previous comfort zone.

12. PATIENCE IS KEY

Remember, your journey is a marathon, not a sprint. Your practice can take time to develop. If you expect instant gratification or results, you will probably be disappointed. Everything, from your style and voice, to relationships with galleries and collectors, will take time to form, foster, and grow.

NOTES 'N' DOODLE

"I have always believed in making my own moves and not waiting on anyone else to pave a way for me. It might be because of my roots in graffiti and just going out and painting wherever we wanted. Also, back in the day, when I was in the punk scene out here, we believed in the whole DIY, do-it-yourself mentality. It all filtered into what I do now as an artist. But I can't discredit the people who have come alongside us and nurtured us along the way. Surrounding ourselves with positive like-minded people has been very beneficial. Supporting my friends, in turn, has always been a good way of building a community around ourselves. The opportunities have always flowed from these connections."

Greg "Craola" Simkins, artist

WHO ARE YOU AND WHAT'S YOUR PURPOSE?

"ALLOW FOR GROWTH, AND DON'T LIMIT YOURSELF BY WHAT YOU ALREADY KNOW AND DO."

CHUCK PARSON

WHO DO YOU WANT TO BE?

Which type of artist do you want to be? That's a very important question to answer as you start to think about your practice. Nowadays, categories aren't so black and white. The direction you choose can overlap with neighboring paths. The graffiti artist with little to no formal education can also be the renowned sculptor who is highly sought after. The poet and actress can also be the conceptual artist who works with neon lights. It's less about how you classify yourself than about the type of artistic life you are comfortable living.

Not every artist will want to make art a career, just as not every professional artist will pursue placing their work in museums. Every artist has a different idea of how they want to exist in the creative world.

When I made the decision to go full-time as an artist, I decided that the artist life I wanted was one where I would be able to financially support myself with my practice. The work I wanted to create would always be exciting and interesting to me, not rooted in just making money. I didn't want to follow art trends or woo collectors to the point of changing my work. I wanted to be able to show in not only museums and galleries, but also make work that could hang in corporate offices and restaurants. I wanted to be respected by my artist peers in every corner of the art world and also have my work be accessible to anyone who enjoys my style.

Artist Theaster Gates is not only a sculptor, painter, and ceramist, but also a teacher, speaker, and most importantly, a social activist in his community. He's a social practice artist: he uses human interaction and social discourse to create social and political change through collaboration with individuals and communities. This focus drives the decisions he makes. Rather than creating art for personal gain, Gates sells art created from items in distressed properties and uses the proceeds to activate the property to be a place for art and public programming.

Deciding what kind of artist you want to be isn't a fly-by-night exercise. It's the core values, philosophies, and standards that you apply to your artistic practice that will help you make decisions on a daily basis, and will ultimately give you comfort and peace of mind.

As you grow, your circumstances will change and you'll have to reevaluate what's important. Dig deep and identify the core values, philosophies, and standards that you want to instill in your practice.

QUESTIONS TO ASK YOURSELF

Write down five living artists who you greatly admire. Research their art careers and practice. Look up their interviews and artist talks online to get familiar with their approach to being an artist. Which kinds of decisions did they make throughout their career?

What core values guide your creativity?

What standards do you want to apply to your practice? What are your *dos* and *don'ts*?

As you distinguish between *career* vs. *art*, are you developing art to fit a market or a market to fit your art?

What makes your life distinct? Now? In ten years? In twenty years?

> *"If we imagine that the only right that we have is to make commodifiable objects, then we limit our practice, and we limit the great potential for an understanding between collectors, curators and galleries."*
>
> **Theaster Gates**, social practice artist

> *"Everybody's path is completely different. I've never seen two artists take t he exact same path... I don't think there's this cookie cutter mold you can apply."*
>
> **Doug Kacena**, artist and K Contemporary Gallery owner

DEFINING SUCCESS

What is success for you? If you don't know, it's time to find out. It's easy to get caught up in someone else's definition of success, leading you down a long and daunting path. You may think that getting into a prominent museum is success, but what if your work there goes unappreciated or visitors just don't understand it? What if your work is well respected by the arts community but you continually struggle financially? Is winning awards a factor in your success? Actors Samuel Jackson, Johnny Depp, and Sigourney Weaver have been in hundreds of successful movies, but none of them have ever won an Oscar. Yet, many actors would kill to be in their position. However you define success, whether it be through financial comfort, artistic achievement, integrity, recognition, or just having the time to create work, having clearly defined goals will help you get there.

"First, are you enjoying this? Second, are you able to pay your bills with this? Is your energy output creating a positive effect to individuals and communities?"

Grow Love, artist and muralist

"I define success as an artist by gauging the people I affect in a positive way. If I can put some smiles on people's faces, I did my job."

Luis Valle, artist and muralist

"My definition of success in this industry is to have ownership over the projects that I complete. Not just to continue to work for other people but to be able to create my own content."

Jai Harris, television producer, MTV/VH1

QUESTIONS TO ASK YOURSELF

What is your purpose for creating work?

What does a successful creative career look and feel like to you?

What are you ultimately looking to gain in your practice?

What does your ideal daily / weekly / monthly / yearly schedule look like?

What values do you prioritize in your life?

What drives you to create?

Are you working toward something greater than yourself?

ART SCHOOL

This is one question that plagues many artists who are looking to take their art to the next level. The short answer is that there is no guarantee you will be successful either way. Art schools, like any other school, vary in the quality of staff, students, and resources. Program offerings will change and the quality of professors and instructors will fluctuate. One way to evaluate your options is to set up meetings with artists who have chosen to go to art school and those who chose to bypass it.

Understand that, ultimately, you can accomplish just as much without traditional schooling. This is not a suggestion to avoid school, but to say that the lack of a degree won't prevent you from achieving your goals. Your success will come from the effort you put into making art, educating yourself, and networking for resources and opportunities. Artist support groups and collectives, art workshops, community classes, art coworking spaces, and networking can also provide some of the benefits afforded by traditional schooling.

The cost, time, and resources that are involved in this decision require that you do a lot of research before deciding. Here are some pros and cons that you'll encounter in this situation.

PROS

You'll be pushed to create work outside of your comfort zone.

You'll have access to spaces, resources, and equipment beyond your current capabilities.

You'll have people holding you accountable for progress.

You'll have access to other creatives who can give critical feedback and support.

A strong alumni connection and diploma can open opportunities in established institutions.

You'll learn valuable skills in other areas of the art industry.

CONS

The cost of tuition and student loans will affect your current and future financial decisions.

Some nonaccredited art schools can close without warning or recourse.

There is no guarantee of success postgraduation.

Quality of professors, staff, and facility can vary.

Schools can breed uniformity and group-think.

YOUR GOOGLES

- Top twenty-five art schools to attend
- Art school grants and scholarships
- Art classes and workshops in (your location)
- Columbia MFA students sue
- Art Institute closes campuses
- Your favorite artist + biography
- Yale Art School alumni
- Pros and cons of art school
- Desired school and program + faculty

QUESTIONS YOU SHOULD ASK YOURSELF

- Can you take one class to start, to sample the program?

- Who are you studying with? Are they working professionals or ivory-tower academics without applied skills?

- Is there a range or current/past and projected future approaches to art making?

- Is this for the "degree" or the education?

- Is an experience with a mentor or an old-fashioned master-apprentice program better suited at this time in your life?

- Is the school currently just teaching what's in vogue?

Charles (Chuck) Parson, artist and professor

"I often reflect on the fact that despite going to an art school for my undergraduate work, the greatest lessons I learned were not solely technical application, but more so strategies for thinking through my process, my concepts, and how I could communicate my intent. Those skills and lessons have become more and more valuable as my practice has grown. Learning how to paint, or draw, or sculpt all comes from committing time and effort into your craft. You don't necessarily need college for that. But the critical thinking piece is essential and I believe this to be one of the most significant values that higher education can provide to an artist."

Dr. Fahamu Pecou, artist and scholar

FINDING YOUR VOICE

How do we define *voice*? It is a thread we weave throughout our bodies of work. Regardless of the work we happen to be creating, our essence, our style, our message, our voice, serves as that work's DNA. To me, voice is more than a recognizable style because styles can be mimicked. Rather, I see voice as a highly personal touch that only you can add. Your voice permeates the work through the materials you choose, the subjects you depict, the processes you use, the way you display, the colors you select, and every other detail of the piece.

Many artists believe voice is tangible, but in my opinion, it's not. You can't put your finger on it or pin it down with words. Rather, it's a feeling. Two actors can recite the same lines and each reciting can create totally different feelings in the audience. Our voice is our unique interpretation of the world and how we want to see it. For many artists, the problem with finding this voice is that it's only found after you've gained experience, lived enough to form your own opinions and thoughts, and feel comfortable expressing them. There are reasons for the choices you make in your work and those reasons are the foundation of your practice.

STAGES OF FINDING YOUR VOICE

MIRRORING

Mirroring other artists is one of the first stages of developing as an artist. We learn, build, and expand on techniques by mimicking our favorite artists. We learn to use oils like the old masters and sculpt like the legends. We study their process and re-create their mediums and techniques. This creates an artistic foundation to build upon.

EXPLORATION

At some point, you have to leave the nest and venture out on your own. With the knowledge you learned from mimicking, you start to then add your own spin to your new works. You try, you fail, you adapt and try again. Pulling from your daily routine, your experiences, your community, and everything else that makes you unique, you start to find the *whys* behind some of your choices. This process can take up to a lifetime for many artists to get through.

GROWTH AND REFINEMENT

Finding that voice that makes your work special is truly a well-earned reward. However, once you find it, you have to refine it. Like an architect who uses her or his voice to go from building small houses to large complexes, you must continually push boundaries with your voice. Creating in new communities and countries, using new mediums, scaling up your work, and working with collaborators are all part of growing and refining your voice.

"I don't really know exactly what happened that made me get to the style I live in now. I do remember feeling excited, though. I was working for a couple of small press magazines doing illustration work for articles and columns around that time. It was my first serious walk into the world of illustration. After a year or so, I noticed that a lot of these little shorthand illustrative decisions I was making to make the magazine work meet deadlines had a sort of personality to them that seemed consistent in its own little vocabulary. After I noticed that, I started pushing more consciously toward those shapes and value modeling motifs more. Characters sort of naturally developed. I started making magazine illustrations about my own life and thoughts and that inevitably became what my work is today. I think style comes when you aren't looking for it."

Birdcap, mural artist, illustrator, and professor

"I remember when I first started, I was thinking, 'Dude, I need my own style, I need to create my own style,' and it was just a tough hill to climb. If you're trying to force something artistically, it just is not a good way to produce art. For me, it started just by incorporating the things I loved. All the cartoons I grew up with, all the cultures I was influenced by. Even now, I still incorporate stuff I saw as a kid."

Juan "Joon" Alvarado, artist, illustrator

"I found my voice early, when I understood that I maintained an extraordinary confidence behind my way of self-expression which has been my art. But I didn't start on canvas, I started on T-shirts in my mom's living room, when I was seventeen. I was influenced by the culture, but confident in my ability to create with a sense of originality. Colors are a spectrum that has always been unlimited for me, and my international travels have influenced my ability to bend color theory when it comes to creating and utilizing distinct colors. The lines I use point to the discipline that I experienced while serving the country in the Coast Guard, as well as me being slightly regimented by nature."

Rob Hill, visual artist, fashion designer

TIPS ON FINDING YOUR VOICE

PULLING FROM YOUR BACKGROUND

Your background is a wealth of experience that makes you one of a kind. Your voice isn't found by looking to others for guidance; instead, it's found by pulling from your unique experiences and using these as tools to create work you're passionate about. Your background as an architect, your family's immigration story, your passion for recycling, your knowledge of fixing classic cars, your school trip to the zoo, are all there to help you create.

FAIL, FAIL, FAIL

Don't be afraid to fail – it's part of the process. You don't know if it's going to work out unless you try it. And if it doesn't, guess what? It's not the end. There may be lost time and resources, but you'll also gain an understanding of what did or what didn't work, and why. Happy accidents that spark new ideas can come from failure. In 1968, Dr. Spencer Silver, a chemist at 3M, created sticky notes after trying to create a super-strong adhesive but accidentally creating a super-weak one. Your failures can be a stepping stone for future projects.

NOT CARING

Don't ever hold yourself back from trying something new because you're afraid of what others may think. We see our work as a reflection of our artistic abilities and intelligence, and when others poo-poo it, we can get self-conscious and limit ourselves to mainstream ideas. You can't allow others to dictate how far you're willing to push yourself. Get weird! From David Bowie to Prince, Jim Henson, Stan Lee, and Picasso, many artists we celebrate today were ahead of their times and pushed forward what it means to be creative.

HAVE OTHERS INFORM YOU

Listening to how your work impacts others can give you valuable insights about the nuances that makes your practice special. Sometimes we can't see the forest for the trees, so listening can help you understand how your process, materials, and subject matter affect people.

BE PATIENT

It may take years to discover your purpose and how you want to share it with others. Many of the small nuances and details that we love so much about another artist's work were refined over long periods of time. Behind those details are dozens, hundreds, or even thousands of attempts. Forcing a purpose in your practice will only lead to your work feeling hollow or unfinished. Take your time and be patient! It's all about the journey as you discover the purpose behind your work and how you want to communicate it.

"My work has evolved through the years to get to the stage it is now. I've always been fascinated with native cultures and their shamanistic, medicinal, plant-based practices. Being uprooted from Nicaragua at a young age had a huge impact on my work. I didn't grow up there, but was born there to parents who lived and breathed Nicaragua and the culture."

"My ancestors' roots run deep through my veins. Growing up in Miami and being mestizo is not the same as being mestizo in Nicaragua. You definitely know you stand out in the US, especially when you cross that Broward County line. This led me to be proud of and curious about my indigenous roots, which then grew into allegiance and affiliation with worldwide native cultures."

"I began to study indigenous shamanistic cultures and found various similarities in them, one being their ritualistic use of art in their healing practices. I also began to notice similarities in some of the techniques and characteristics of the artwork. I began to conclude that all these cultures had a common root that was not of this world and based in a realm of the imaginary mind and other dimensions. One characteristic I found similar in many of these societies was the use of color and the dot or circle pattern to represent energy, frequency, vibration or spirit. I saw how pre-Colombian, aboriginal, and African cultures, to name a few, used the circle in a similar way to enhance the art. This started over twelve years ago and has slowly evolved to its present form in my work."

Luis Valle, artist and muralist

CASE STUDY: THE VOICE OF JR

To help grasp the concept of voice, let's take a quick look at the street artist JR. JR, known for his large-scale wheatpastings of portraits, started out as a graffiti artist on the streets of Paris. Only after purchasing a camera did JR start to document his projects with his artist friends. At seventeen, he started pasting small photocopies of pictures on walls and framing them with color so they wouldn't be mistaken for advertisements. He called this a street gallery. He did not want to go through the traditional gallery path that would decide whether his work was good enough to be seen; instead, JR slowly developed his street galleries all across Paris.

It wasn't until November of 2005, during a series of riots in Paris, that JR realized how powerful paper and glue could be. JR's illegal wheatpastings of portraits of his friends in the Les Bosquets neighborhood were visible in the background of news footage documenting the Paris riots. His work became associated with the riots and was viewed through a negative light. He knew that this wasn't his intention, so he went back out to Les Bosquets with his camera and a 24mm camera lens.

With a 24mm lens, the only lens he had at the time, taking portraits was an intimate process, as it requires you to be close to the subject. He took full portraits of the people from Les Bosquets and created large wheatpasting portraits around Paris. Within a year, JR's wheatpastings were proudly displayed on the front of Paris' city hall.

JR continued this approach by traveling to Palestine and Israel during a time of heavy regional conflict. With the help of individuals on both sides of the wall, he took photos of Palestinians and Israelis with similar jobs and wheatpasted them side by side in eight Israeli and Palestinian cities. Called "Face 2 Face," it was an attempt to be the largest illegal street exhibition ever.

JR continues to tackle tough issues surrounding perception and image around the world. His style has qualities that can easily be mimicked if desired. However, the choice of materials, processes, locations, and subjects all have reasons that are specific to JR's experience. Regardless of each project's medium or tools, JR's voice rings loud throughout each of his projects.

His road to finding his voice has been long and winding. It took more than a decade for JR to find and mature his voice. It may take you the same amount; maybe longer or shorter. The point is that it's different for everyone, so just enjoy the journey.

- Artist JR
- Artist JR + Face2Face
- Artist JR + Portraits of a Generation
- Artist JR + US–Mexico border art
- Artist JR + Inside Out Project
- Artist JR Ted Talks + YouTube

JR

ADAPTING YOUR LIFESTYLE

Setting your goals high is perfectly reasonable so long as you're willing to put in the work needed to accomplish them. It is a given that you will encounter hurdles in life that could steer you away from becoming a better artist. An analogy that we can all relate to is eating right and exercising. While we all want to have healthy bodies, most of us live lifestyles that prevent us from achieving that goal. We eat fast food, sit for extended periods of time, don't get enough rest, and avoid physical labor, even while telling ourselves that we are going to get healthy. Think of those New Year's resolutions that fade away before the end of January. As many trainers will tell you, the problem is that you're not incorporating good daily habits to facilitate a healthy lifestyle.

It's the same with art or anything else you want to excel at. You'll need to adopt lifestyle choices that will directly or indirectly benefit your practice. My first year as a full-time artist, I did weekly live art gigs that allowed me to learn how to use acrylics and paint faster, all while hanging out with friends and selling artwork on stage. I was able to subtly improve my technique without even thinking about it. I love working with kids and volunteering, so any volunteering that I do always involves teaching kids about art. Finding ways to incorporate daily, monthly, and yearly activities to improve your practice requires you to engage in thoughtful conversation with yourself about how you learn.

SUSTAINABLE

The lifestyle change you choose should be a sustainable activity that you can add to your daily habits for an extended period of time. Unlike a fad diet, you want to be able to continue this activity without causing negative feelings or undue stress.

SUBTLE

Subtlety is all about adapting your lifestyle in small increments so new actions don't feel like work. These changes can take relatively little effort while still providing benefits. For example, using a bike as your main transportation will indirectly make you healthier because of the physical exercise your body receives.

NONINTRUSIVE

Activities that are nonintrusive don't feel as if they are interrupting your daily routine. Making sure your lifestyle changes are nonintrusive can help you integrate them better into your life.

HOMEWORK

What are some of the activities in your life that are time, resource, or energy wasters? (Watching television, buying video games, scrolling on social media)

How can you replace those activities with other activities that will benefit your practice?

CREATE, FAIL, LEARN, REPEAT

"CREATIVITY IS JUST CONNECTING THINGS.
WHEN YOU ASK CREATIVE PEOPLE HOW THEY
DID SOMETHING, THEY FEEL A LITTLE GUILTY
BECAUSE THEY DIDN'T REALLY DO IT,
THEY JUST SAW SOMETHING.
IT SEEMED OBVIOUS TO THEM AFTER A WHILE.
THAT'S BECAUSE THEY WERE ABLE TO
CONNECT EXPERIENCES THEY'VE HAD
AND SYNTHESIZE NEW THINGS."

STEVE JOBS

EXPANDING YOUR CREATIVITY

Creativity comes from synthesizing multiple ideas. As it's said in Ecclesiastes 1:9, "There's nothing new under the sun." This is true, so it's incumbent upon you to seek out existing ideas to make new ones. Your brain is the most complex organ in your body. Composed of a network of billions of neurons firing at all times, your brain is the key to opening all your creativity. Like strengthening a muscle, you need to consistently exercise your brain to see things that others don't, to ask questions when others follow, and to piece together different ideas to create something new. As an artist, don't sit around waiting for inspiration; go out there and take it.

SKILL BUILDING

Learn to use every resource that's available to you: woodworking, ceramics, welding, computer programing, oils, spray painting, baking, photography, playing music, and more. Opening yourself up to learning new skills will allow you to expand your creative flexibility and use a wider range of media to express your ideas.

DON'T SIT AROUND WAITING FOR INSPIRATION. GO OUT THERE AND TAKE IT.

CROSS-POLLINATION

When two or more existing ideas combine, there is an opportunity for something exciting to be born. This idea is beautifully exemplified in the work of street artist duo PichiAvo. PichiAvo paints large-scale murals and gallery works that incorporate the visual language of graffiti with classical Greek sculpture. By combining these two styles, PichiAvo amplifies each one in a new way.

TRAVEL

Traveling is the most efficient way to get outside of your comfort zone. Being fully immersed in a new environment allows your routine to be shaken up and disrupted. The small but significant nuances of different cultures and environments, with their unfamiliar colors, sounds, and other elements, can spark new inspiration. It can be valuable to study abroad or to attend an international residency. Think of traveling for the arts as an investment in your career.

"Take time to play. When I'm 'working,' I'm also giving time and space to play. Play creates a space for failed projects and endeavors, but that's also where I find my next successful endeavors. If you're always working and doing the same things, there is no growth. I move quickly with my inspiration. If I don't get it out or try it within a couple weeks, I'm over it and move on. My last show was thought of, applied for, and completed within four weeks. I like creating and building and working hard. It's my disposition."

Grow Love, artist and muralist

COLLECT STIMULATION

Your creativity feeds off the stimulation of everyday life. Throughout the day, you encounter sights, sounds, patterns, color palettes, smells, and more. As an artist, you have to be a collector of the things you love, almost a hoarder of carefully curated ideas. With the power of a phone, you can capture the stimulants that catch your eyes and ears. Get into the habit of documenting everything that influences and moves you. You can document using an album on your phone or a folder on a laptop.

KEEP A NOTEBOOK

You'll have thousands of ideas that pop up throughout your daily life. Like me, you'll likely be preoccupied and will promise yourself that you'll remember the idea for later; and, like me, when later comes, odds are, it will have completely slipped your mind. Keeping a notebook to write down all your ideas is paramount. Whether this notebook is paper or digital, having something you can use to write in at all times will prove instrumental in helping you build a creative diary.

COLLABORATION

Working with other artists will help you to explore tools and concepts through different lenses. Being able to collaborate with other artists will help you learn new skill sets and ways of thinking creatively while practicing your craft.

TAKE A DETOUR IN LIFE

"When in Rome, do as the Romans do." This sage advice is perfect for when you want to fit in with mainstream culture, but less good for encouraging creativity. Rather, you have to be the nail that sticks out. You have to be the one who will ask the question others don't. You have to be the one who ventures outside the boundaries and do the things that others only talk about. You have to be the person who is willing to take big risks. Don't expect to become great if your life is full of mediocrity.

YOUR GOOGLES

- Skillshare.com
- PichiAvo + artist
- Ai Weiwei biography

- Jimmy Nelson – Before They Pass Away
- International art tours
- International art residency

NOTES 'N' DOODLE

"I need to stay excited. The best feeling is when you feel on the verge of figuring something out, but you're not quite there yet. Spray paint is sort of wonderful in that way because it's always a little out of reach. If I make a toy this year, that's exciting. If I make a mosaic or a graphic novel, that works too. You make art for a million reasons, but at the root it has to be self-edification, and for me that's trying to do something every year that I just couldn't have done the year before."

Birdcap, mural artist, illustrator, and professor

CREATIVE BLOCKS

There will be many times when it's hard to tap into your internal creative well. These instances are usually when your time and energy are stretched thin or when there's too little activity in your life. Often, creative blocks can be tied to your mental and physical health. You feel mentally fatigued from personal circumstances and pressures, or physically drained from illness. It's as if you get exhausted from simply trying to think. Rest assured that this lull in creativity is normal. Any artist you can name has had to overcome creative blocks.

At the core of creative block is the inability to create new ideas from your existing ones. Imagine if you had a vocabulary of 5,000 words but routinely only used 2,000 of them in conversation. Your verbal expression would be extremely limited. Now, imagine if you regularly used all 5,000 words in your daily conversations, while consistently increasing your vocabulary. You would be a true wordsmith.

By trying new activities that help open your mental valve, you will be better able to tap into your subconscious. Exploring ideas is part of the creative process, so don't hesitate to mix things up.

ACTIONS TO BREAK CREATIVE BLOCKS

Become a multidisciplinary artist.

Take a break from the studio.

Mix ideas and concepts you wouldn't normally mix.

Work in a new environment.

Change the time of day you create.

Pinpoint a specific goal in your creative session.

Borrow ideas from unrelated art forms and industries.

Revisit old ideas.

Keep a creative journal.

YOUR GOOGLES

- Creative exercises
- Creative blocks
- Writer's block

> *"I think creative blocks come from a lack of developing and nurturing your creativity. Being a creative or an artist is about the strength of the mind imagining, seeing differently, or observing and pondering ideas and concepts. It is more important to exercise that muscle than it is to merely focus on the skill set or tool the artist uses. There is so much in the world to analyze and so many experiences to ponder. Being an artist and creative is an intellectual practice and it requires a lot of thinking."*
>
> **Ronald Jackson**, fine arts painter

> *"Usually if there is a creative block, it's a sign I need to shift my energies, which I am more than grateful to do. It gets stuffy sitting in the same places too long. I know that I can always come back to things or not! Fluidity within the creative process is so important. Be gentle with yourself. Know that inspiration can just be a short walk away, so take care of yourself, be good to yourself, so that you can come back to your work and space invigorated."*
>
> **Grow Love**, artist and muralist

> *"I've found that for me, one of the best ways to get over a block is patience. I believe in thinking an idea through fully before I begin to work on it. And self-care is another essential aspect for creative people. My wife often reminds me to relax and unwind between projects. Those moments of pause are just as powerful and intense as the time I spend working."*
>
> **Dr. Fahamu Pecou**, artist and scholar

TIME MANAGEMENT

Protect your time just as much as your protect your wallet. It's the only thing that you can't get more of, so don't let others waste it. As I have grown older as an artist, time is different. It has more value. I now protect my time because I need to dedicate as much of it as possible to creating. Parents and caregivers know this all too well.

ORGANIZING

One of the most important part of time management is organizing your schedule. Keep a calendar or a planner that you can religiously refer to for daily tasks, project deadlines, progress reports, and meetings. Prioritize these categories as you see fit for your practice. I refer to my Google calendar, which I update on a daily basis, for my daily tasks, and set reminders for upcoming projects far in advance.

PROTECT YOUR TIME JUST AS MUCH AS YOU PROTECT YOUR WALLET. IT'S THE ONLY THING YOU CAN'T GET MORE OF, SO DON'T LET OTHERS WASTE IT.

ELIMINATE TIME WASTERS

Eliminate people, activities, and items in your life that eat up your valuable time. This can be everything from preparing you lunch so that you're not battling traffic to pick up food, to upgrading or replacing slow equipment. Take time to analyze your daily activities and find ways to cut the fat.

DICTATE YOUR SCHEDULE

Whenever possible, dictate your own schedule. Don't let others do it for you. When scheduling a meeting, have a day and time ready rather than asking others what works for them. The more you dictate what your schedule will be, the more efficient you can be.

HOMEWORK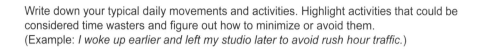

Write down your typical daily movements and activities. Highlight activities that could be considered time wasters and figure out how to minimize or avoid them.
(Example: *I woke up earlier and left my studio later to avoid rush hour traffic.*)

Don't have a planner? Purchase one now and start getting familiar with a calendar app that you can use to schedule your studio tasks and meetings.

YOUR STUDIO PRACTICE IS WHAT YOU MAKE IT

"ARTISTS HAVE THEIR STUDIOS LIKE SUPERMAN HAS HIS FORTRESS OF SOLITUDE."

THOMAS "DETOUR" EVANS

STUDIO SPACES

YOUR FORTRESS OF SOLITUDE

Your studio should always be your fortress of solitude. It should be the place that gives you the creative safe space that you need to explore and create. Your studio should also serve as a place to invite collectors, curators, and gallerists to see your work and your process.

My studio has hosted hundreds of meetings and gatherings, from collectors wanting to meet me first before purchasing my work to art apprentices looking to help me out in the studio. Think of your studio space as an asset in your career. For many artists, like myself at one point, the kitchen, basement, or garage will serve as a studio. This is perfectly fine. Whatever space you decide to use, just take into account how to best arrange your space to deal with your equipment, scale, ventilation, sound buffering, and cleanup needs.

MEMBERSHIP / COWORKING SPACES

In membership and coworking spaces, creatives pay a membership fee for access to both space and creative equipment. This equipment can include tools for printmaking, metalworking, carpentry, prototyping, ceramics, and other disciplines that are difficult to acquire on an individual's budget. This is a great option for artists who need expensive tools or industrial equipment. Coworking spaces are becoming increasingly popular in cities with shrinking access to dedicated studio space.

FINDING ARTIST SPACES

One of the best ways to find a studio is by networking in the artist community. Art spaces can be eccentric, so studio rentals are not always listed online. Rather, many are advertised through word of mouth: "An artist friend of a friend knows of a studio that is opening up." My first studio was located in a newly renovated building that used to be a Jewish temple. The owner Adam Gordon and I have been friends for many years, and it was through our friendship that I found a cozy home for all my paints. Other resources, like listing sites or your local arts district office, may result in good leads as well.

YOUR GOOGLES

- Art studio spaces + (your location)
- Creative studios + (your location)
- Warehouse spaces + (your location)
- Arts district in (your location)

STUDIO PRACTICES

- A studio is a mind-set.

- Be selfish with your earned studio time.

- What time of day is your most focused? When do you have a clear pocket of time to work?

- If it takes three hours to get one hour of work done, make a change in the time/place you work. Focus!

- Distinguish between working in your studio on your *career*, as opposed to the time you spend working on your *art*.

- Have a body of art developed before projecting a career profile at a "higher bar."

Charles (Chuck) Parson, artist and professor

"Know who your visitors are. If you have different bodies of work and you are inviting people into your space, it's nice to set up the studio to direct the eye, as opposed to having a studio that is completely packed."

Louise Martorano, executive director of RedLine

SHARED STUDIOS VS. PRIVATE STUDIOS

It is common for artists to share spaces with other artists. With rising rent, splitting costs in some form is a good option. Sharing space with another creative can also be beneficial to your practice. My first ever studio mate was an artist by the name of Andrew Huffman. His eye for detail and technique filtered into my practice, which helped me grow as an artist. Review some of the pros and cons of private and shared workspaces to help you decide how to pick a studio.

PRIVATE STUDIO SPACE

PROS

Larger space to create work

Total control over curation of the space

Always available as a meeting space for collectors and studio visits

Fewer restrictions on materials and studio cleanliness

CONS

Can be costly to rent or lease

Decreased frequency of instant feedback and critical discussion with another creative

Decreased chances of networking opportunities

SHARED STUDIO SPACE

PROS

Sharing the cost of the studio will bring down monthly expenses

Easy access to a like-minded creative for critiques and discussions

Widening of your artist network and increase in opportunities

Possible collaboration and artistic growth through shared knowledge

CONS

Less space to scale-up work

Need to schedule planned meetings and studio visits with studio mate

Necessary to accommodate for sound, materials, and space limitation

Possible personality and/or studio cleanliness clash

Less privacy

HOMEWORK

Think about the needs of your practice. What space, noise, material, and location requirements do you need for your practice to thrive? Also, what is needed to take your practice to the next level? This is a great time to think about a future studio goal to work for.

What are the costs of having a solo studio vs. a shared studio space in your area?

Which locations in your current area are best for your studio when it comes to networking and creative synergy with other artists?

How should you arrange your studio to accommodate guests?

CONCEPTS MATTER

Famed photographer Ansel Adams said it best: "There's nothing worse than a sharp image of a fuzzy concept." Artists can get so caught up in the details of a body of work that the message is lost. Have you ever seen a movie that was shot beautifully, but the story or plot line was horrible? I think we all have. Well, visual art is the same: the meaning, the story, the concept behind the work is its backbone. In its absence, the entire work can feel hollow.

Pablo Picasso's *The Bull* is a series of eleven lithographs that take viewers on a journey to simplicity. In search of the true spirit of a bull, Picasso uses the process of reduction on each successive plate until only a few lines represent the bull's essence. *The Bull* puts the concept of simplicity, reduction, and essence to the forefront, sparking thought and engaging the viewer.

My first photography exhibit featured a series of photographs of African Americans in the community using and wearing African artifacts from an art collection. DNA testing on each individual was conducted to link the subject's lineage with the artifact used in the photo. The exhibit wasn't about the photos – that was just the medium I used as a vehicle for the concept: the idea of the African diaspora, lost history, and rediscovery.

As a practicing artist, you will have to explain your concepts to others. Grants, artist statements, applications, curators, and collectors all want a deeper understanding of the ideas you're exploring. Get comfortable with communicating to people why they should be curious about your work.

YOUR GOOGLES

- Georgia O'Keeffe
- *The Bull* + Pablo Picasso

- Artist talks MoMA
- TED Talks art

NOTES 'N' DOODLE

MATERIALS

The materials an artist uses can be just as important to the artist's identity as to the work itself. The materials in a piece serve as its DNA, in that it can tell the viewer a great deal about the work's history and the artist's intention. When was it made? How was it constructed? Was it a study, or was it intended for a collector? How will the work hold up over time? Does the material add to the artist's concept? With which part of the artist's career is the work associated?

Materials should be as important to your practice as the concept behind your work. Being able to explain why you chose to use reclaimed wood instead of Chinese steel, used cotton instead of high-quality silk, or handmade oil paints instead of acrylic can deepen connections between the work and the viewer.

Push the boundaries of the materials you use but venture outside of your comfort zone and expand available materials in your studio. You don't know what you don't know, so explore the material landscape.

CONSERVATION

When exploring materials, artists should always keep in mind the durability and longevity of the material in question. You will need to know what effect time and environment may have on your choice of materials. Take a tour of any museum with prominent works, like the Tate Modern or the Museum of Modern Art. Many of the historical paintings there have been restored by a trained conservator. Even well-kept works will experience the effects of aging. Now think about interactive work. How, with all the advancements in technology, does a museum preserve a work that includes vintage technology? It's something to think about.

Which topcoat do I need to protect my work? Will the sun or humidity affect the color or materials in my work? How mobile is it? Can my work be easily stored long-term? People who acquire art are surely asking these questions. Artist Damien Hirst's work titled *The Physical Impossibility of Death in the Mind of Someone Living* featured a shark suspended in formaldehyde. Selling for $12 million dollars, one would think that the piece would last for a reasonably long time. However, because the initial preservation of the shark was poor, the shark started to decay. Don't let laziness or a lack of research blindside you or your collector.

With a wide variety of new materials we use in the studio today, conservators are always learning how to preserve new works. Always research the materials you're using with this in mind.

YOUR GOOGLES

- Contemporary art conservation
- Modern artwork conservation
- Mark Bradford art materials
- Donald Martiny

- Andrew Tirado
- Damien Hirst
- Giovanni Contardi + Rubik's cube artist

INSPIRATIONAL ARTISTS USING UNCOMMON MATERIALS

- Lillian Blades
- Mark Bradford
- Giovanni Contardi (Rubik's cube artist)
- Damien Hurst
- Stephen Knapp (light installation)
- Donald Martiny

- Jamie Molina (art + doll)
- Eric Rieger, aka HOT TEA
- Christophe Roberts
- Benjamin Shine (Tulle Works)
- Andrew Tirado
- Frankie Toan (textile art)

"Every approach, for me, is from the perspective of interrogating my subject rather than trying to define it. I question everything, including my own firmly held beliefs. I believe in turning everything on its head, taking things apart and putting them back together. I think, in this way, my audience, too, is required to do some work. That approach leads to a number of discoveries as well as opens up new modalities. Because I ask these questions, I began to realize that in many cases, different approaches or mediums are then required. What I can say through painting may not be enough on its own. Perhaps a drawing works better with a particular concept, or a video, or a performance. The benefit of this is that these varying expressions also lead to creating multiple points of entry for the audience to then engage and experience the work."

Dr. Fahamu Pecou, artist and scholar

THE TOOLS WE USE

You can drastically expand in your practice by diversifying the tools you keep at your disposal. The tools you create with can drastically shift the outcome of the work, in texture, shape, size, and more. A landscape painting on a small canvas can be enlarged on the side of a building using spray paint, and then further transformed into 3-D with augmented reality. Experimenting with a range of tools allows you to explore nontraditional forms of creating.

SWITCH IT UP

Every tool can give a different result. Craig Costello, better known as "KR," developed a style that uses a pressurized fire extinguisher to dispense latex paint. The scale and texture created by this tool sets Craig's work apart because of its unique qualities that aren't easily duplicated with traditional tools. Other artists, like myself, use equipment such as CNC machines, laser cutters, and 3-D printers to fabricate works that are almost impossible to create with the human hand.

THE MORE TOOLS YOU LEARN TO USE, THE MORE CREATIVELY YOU'RE ABLE TO SOLVE PROBLEMS.

TOOLS TELL A STORY

Not only can the tools you use change how you create, but they can add depth to your work. Musician Flip Baber, better known as Johnnyrandom, composed a symphony entirely out of the sounds produced by bike parts. By using unconventional tools, Baber added a layer of interest and complexity to his work. Tools tell a lot about the artist: their unique hobbies and interests, their willingness to experiment, and their ability to be creative. Many of the tools I use can be purchased not in an art store, but at your local hardware store.

Knowing the *why* of your tool choices helps you to better understand your work. Why am I using this tool? Is this the right tool to execute my concept and vision? Is there another kind of tool I can experiment with? How is this tool different from what other artists use? Asking yourself these questions will allow you to self-critique and improve your practice.

YOUR GOOGLES

- Françoise Nielly paintings
- Tatsuo Horiuchi Excel paintings
- Steven Spazuk fire paintings
- Craig Costello art
- Danielle Clough art
- Griffon Ramsey art

- Ansel Adams
- Desktop CNC machine
- Desktop laser cutter
- Desktop 3-D printer
- Flip Barber + Johnnyrandom

HOMEWORK

Visit your local hardware store and browse the items on display. Investigate their function and write down how each could be used to enhance your creative process.

PROCESS

The thread that ties the tools you handle and the materials you use is the process used to create the work. Process is an entire journey in itself. For many artists, the end product is not the principal focus, but only the evidence of the creative process, which is the true art. Just as you need to put thought into your materials, you also need to think about process. If process were a part of language, it would be the way you arrange words to create poetry. Ten different writers can use the same set of words to create ten vastly different poems.

> FOR MANY ARTISTS, THE END PRODUCT IS NOT THE PRINCIPAL FOCUS, BUT ONLY THE EVIDENCE OF THE CREATIVE PROCESS, WHICH IS THE TRUE ART.

Artistic process can take many forms. Artist Riusuke Fukahori is best known for his resin-based studies of goldfish. Fukahori pours multiple layers of clear resin between layers of acrylic paintings of goldfish. The result is a surreal, three-dimensional freeze-frame of aquatic life. By understanding the process behind his work, the viewer can appreciate the thoughtfulness and patience necessary to create it.

DEVELOPING PROCESS

Developing process is not a singular event. Instead, it is an ongoing process of discovering where your limitations are and how to push beyond them. Developing process requires you to understand the importance of risk and experimentation. Not all your ideas will work, so be comfortable with failure – that's part of being an artist. You need to experiment constantly with new processes, all while asking yourself, "Why?"

YOUR GOOGLES

- Bisa Butler
- Seth Casteel photography
- Gabriel Dawe
- Edmond de Belamy + obvious art
- Riusuke Fukahori
- David Garabaldi
- li hongbo paper art

- Titus Kaphar
- Ayn Kraven + art
- Sigalit Landau
- Jackson Pollack drip period
- Jonathan Saiz + #whatisUtopia
- Alfons Schilling spin painting

"Whether it be citing materials, or exemplifying the process, or how materials were gathered or exchanged, by examining works [by artists] such as El Anatsui... audiences engage immensely from stories about transference of materials and process to better understand and appreciate the work. It is a language of labor."

Antoine Girard, artist, curator, and Broad Art Museum staff member

"Process is important because for one, it helps produce consistency in my work. And for me, I've learned that my concepts start with ideas and later unfold with more clarity and vision. My conception process is more of an organic thing – it's just the way ideas come to me. My working process is more of a set of systems that I employ to help guide my workflow to eventually manifest the concept."

Ronald Jackson, fine arts painter

RESEARCH

Use the power of the Internet and books to find information about your area of focus. This research can reveal interesting connections between different ideas that can influence the way you create and arrange elements.

Artist Titus Kaphar uses research to learn more about the roles African Americans played in historical paintings during the era of slavery. What results is a unique process that encourages conversation about his ideas. By cutting away at an existing painting to reveal another painted layer of canvas beneath, and adding paints and fabrics to obscure the intended focal point, Kaphar shifts the focus and narrative of the original work.

Kaphar's process displays the intentionality of his practice. Take time to research the ideas you want to talk about. How can I use materials to talk about the underlying message? How does time play a role in my concept? Will the surrounding environment influence viewers' understanding of the work, and how can I incorporate that intentionally? You'll need to answer those questions and more as you to start to develop and refine your own creative process.

LOOK TO YOUR STRENGTHS

When exploring ideas of process, your strengths are a great place to start. Often, we overlook some of our talents because we take them for granted. Your background and experiences are rich with materials you can bring into your studio. These strengths can be anything from skills you gained through your previous occupations to relationships you forged while traveling the world.

DON'T LET THE PROCESS OWN YOU – YOU OWN THE PROCESS

You have a responsibility to yourself and to your work to make sure you are always pushing the boundaries. To grow, you have to be unafraid to make mistakes. Famed painter Jackson Pollock is best known for his drip paintings. Many don't realize that this period only lasted for about three years. He was willing to venture into unknown territory, rather than repeating the same process indefinitely.

HOMEWORK

What do you want your work to talk about and why is it important?

What experiences make you unique?

What skills do you possess?

Is time important to your process?

Is space, or the environment in which you create, more important to your process?

Is there an element of randomness to your process or is it controlled?

Is there another way you could be creating work?

ARTIST STATEMENT

At first, like many young artists, I viewed artist statements about my work as time-consuming and unnecessary. "I did it because I like it" is what many of us have said. Although true, viewers want to know the story behind the story. Viewers want to know the who, what, when, where, and why. They want to know your intention behind the use of a certain color, or your fascination with a particular process. Essentially, viewers want to know why your work exists and why you chose that particular way to express your ideas. You will not always be there to explain your work to everyone who inquires, and in those moments, your artist statement represents you.

No one statement fits every occasion. Each body of work you do may require you to edit and to update your statement. One of the best approaches for this is to start a folder with multiple drafts of your artist statement. Some parts of your statement will stay the same, while other parts will vary slightly. Your statement will evolve as you evolve, so continually revisit your statement and reflect on that evolution with edits.

NO ONE STATEMENT FITS EVERY OCCASION. EACH BODY OF WORK YOU DO MAY REQUIRE YOU TO EDIT AND TO UPDATE YOUR STATEMENT.

One of the routine exercises that sharpens my communication skills is to constantly talk about my work with people of various backgrounds. Continuously explaining and justifying decisions you made in your practice will help you better understand your own work. Sometimes, you're able to hear perspectives about your work that you weren't expecting. Having these conversations brings about effective words and phrases that can be added to your own artist statement(s).

One of the best ways to get started is by learning by example. By researching artist statements and works from some of today's leading artists, you will begin to understand how to effectively communicate, in written form, what your work is about. There's no magic word count on how much you should write. It essentially comes down to, "Do readers know why you create _____?" To start crafting your artist statement, begin by thinking about the following areas and jot down your thoughts.

YOUR GOOGLES

- Damien Hirst artist statement
- Jordan Casteel artist statement
- Miss Van artist statement

- Widewalls artist database
- Artsy.net artists

QUESTIONS TO ASK YOURSELF

What philosophical question or sociological issues does your work tackle and why?

What is your background and how does that influence your practice and work?

What type of research did you conduct to create your work?

What is the process behind your work and decisions?

What does your process for creating work look like?

Why are you interested in this subject matter?

What is the significance of the media, materials, and techniques?

What are some of your studio-based practices?

Are there any references to time period, or to events that influence your practice?

What do you want your audience to get from your work?

> *"Be prepared for a 30-second or 1-minute verbal statement. A common question in professional settings is 'What do you do?' Always have an image or two/plus that you can share. Anything hard copy to leave with an interested person, or to send over the Internet. Have a speech writer assist in grooming it to perfect it."*
>
> **Charles (Chuck) Parson**, artist and professor

> *"History... What inspires you? What was the basis for your project? Was it being exposed to more of this, or a lack of something so you attempted to fill the void with your work? I think art with no or limited meaning can sometimes linger in visual appreciation but no impression of a lasting effect. Language of this history can excite new audiences to the work."*
>
> **Antoine Girard**, artist, curator and Broad Art Museum staff member

ARTIST CV 101

As an artist, you'll need to start thinking about writing your résumé or CV, which stands for curriculum vitae, and loosely translates to "course of life." Your CV is a written document of what you have done in the past, and typically includes details about your education, employment, exhibitions, awards, residencies, and any other significant activities.

This document helps juries, committees, schools, galleries, and other organizations determine if you are the right fit for a particular opportunity, whether it be a new public art commission, museum show, fellowship position, and so on. Ideally, a CV is between 1–2 pages, but if the first point of contact is the Internet, your digital CV stretch this and run a little longer. Because your CV emphasizes your accomplishments, it serves as a living, chronological document that you'll need to frequently update to reflect your most current activities.

HEADER
Contact information | Current City location | Date and City of Birth

EDUCATION
Year, Major/Degree, School

SOLO EXHIBITIONS
Solo Exhibits throughout your career

GROUP EXHIBITIONS
Group Show Exhibits throughout your career

RESIDENCIES
Residencies you have attended

AWARDS, GRANTS, AND FELLOWSHIPS
Awards, Grants, and Fellowships you have received

PUBLICATION AND PRESS
Reviews and Media Coverage you have received

COLLECTIONS
Museum or prominent private collections your work is in

HOMEWORK

If you don't have a CV, open up a document on your computer and start writing. Below is a list of prompts to help make sure that you have the details you need. Go down the list and check off all the items to make sure your CV is as strong as it can be.

- ◯ Show all relevant information in the header.

- ◯ List all relevant educational accomplishments (exclude high school).

- ◯ Prioritize all significant solo and group exhibitions.

- ◯ List all relevant residencies.

- ◯ List all recent and relevant awards.

- ◯ List all recent and relevant press coverage and reviews.

- ◯ Remove all irrelevant and outdated information from your CV.

- ◯ Ensure the CV is easy to visually scan to capture the gist of your experience.

- ◯ Make sure that all the information is accurate and up-to-date.

- ◯ Ask two or more people to proofread the CV.

> "When it comes to CVs and exhibition opportunities, I think it's good to show that you have shown in a gallery, or museum or some kind of public space to show that you can responsibly install and execute a professional exhibition. I also think showing curators you have worked with or certain institutions of note, like a museum, on a CV gives you a leg up as well. Show the diversity of venue, and size of venue, and if there is any name recognition in the venues and curators you have worked with, prioritize those over group shows you had in venues multiple times."

Louise Martorano, executive director, RedLine

ART CRITIQUES

Making your art in a safe space is easy. Putting your art out to the world for people to experience, review, and critique is emotionally challenging, but necessary. One of the most important things I understood about my work, and especially about my street art, is that not everyone will view my work the same. I may think I'm communicating a message clearly but something about the colors I chose might prevent my message from being digested. It's often necessary to have multiple people (with multiple perspectives) experience your work, so you can effectively refine details.

Critiques are how artists of all forms sharpen their craft. Stage performers, such as comedians, have live feedback during their shows. It's not always easy to hear opinions that are critical of your artistic decisions, but your work evolves in a way that is a little more refined. To fully gain all the benefits of a critique, ensure the following:

WELCOME A DIVERSE GROUP OF ART CRITIQUES

Having a diverse critique group, with multiple perspectives, will help your work get analyzed from every angle. I regularly shoot ideas at and request suggestions from a group of trusted individuals. Include not only artists, but curators, galleries, critics, and professors. This group doesn't have to meet or even know of each other. It can be as simple as having a good relationship with each individual and receiving occasional feedback through studio visits, lunches, text, social media, and other daily interactions.

ONLY TAKE IN CONSTRUCTIVE CRITICISM

Not all feedback will help your work. You don't have to internalize every critique that is thrown your way. Sometimes you'll receive feedback that can be destructive, confusing, illogical, and that completely misses the point on how it will improve your work. You have the option to decide which critiques to use and which to set aside.

NEVER TAKE IT PERSONALLY

Critical feedback is a tool that can help your work translate better, and it is not an indictment on you as a person, or artist. Separating yourself from the art not only helps you hear feedback without feeling the need to engage defensively, it can even result in you feeling more free to experiment in the studio.

YOUR GOOGLES

- Art critique workshop + (your location)
- (Your location) + artist meet-up

"I have a take-it-or-leave-it mentality. I've found that any feedback is good feedback, but I don't have emotional or egoistic responses either way. It's just information. It could be helpful or not, it can be super inspirational or not. I have a lot of trust – or have developed a lot of trust – in my own hand and heart. But we all know at the end of the day it's collective consciousness that is dictating everything!"

Grow Love, artist and muralist

NO ARTIST IS AN ISLAND — WE ALL NEED SUPPORT FROM TIME TO TIME

"ART IS FUNDAMENTAL, UNIQUE TO EACH OF US... EVEN IN DIFFICULT ECONOMIC TIMES – ESPECIALLY IN DIFFICULT ECONOMIC TIMES — THE ARTS ARE ESSENTIAL."

MARIA SHRIVER

SPONSORSHIPS 101

The reach of artists and their work can now span across the globe. As artists increase their level of influence through the Internet and social media, companies and organization are taking a closer look at how they can use sponsorships to tap into an artist's network. These sponsorships are all about facilitating a mutually beneficial relationship between an artist, the artist's goals and dreams, the company, and a mission. These relationships can be short-term and project based, or they can be long-term and ongoing.

While some artists look at sponsorships or endorsements as a means of financial support, I have a different perspective. In my mind, a sponsorship gives me a chance to tap into a business's resource and talents. Think beyond simple endorsements and ask yourself, "How can this business help contribute to *my* practice and how can my practice, in turn, help the sponsoring business?" As you approach a sponsorship opportunity, think beyond just slapping a logo onto a flier of an exhibit in exchange for cash. Ask yourself:

How can a sponsoring company contribute to the creativity of my practice?

Is there a particular item or service I need for a project but it's costly to acquire?

Could the company help cover the cost?

Could the company help promote work that I've created using their products? (Example: paint companies often showcase amazing works by artists that utilized their products in the process.)

MAKING FIRST CONTACT

As you think of a company as a possible sponsorship partner, also consider the company's brand – that bigger picture of how the public perceives a company or a product or a service. Getting the attention of a brand in this day and age is not as difficult as you think. With social media and Google, you can find contacts for many of the largest brands in the world. Not only that, tagging and direct-messaging brands on social media works better than you might think. There's always someone watching. Usually these are seen by social media managers who will send your messages to a manager higher up in their chain.

TYPES OF SPONSORSHIPS

Financial contribution for exhibit or project	Promotional services
	Fabrication services
In-kind donations of supplies and material	Event space rental
	Media sponsor

YOUR GOOGLES

- Brand + sponsorship opportunities
- Brand + Instagram
- Brand + Facebook
- Brand + marketing manager + LinkedIn

NOTES 'N' DOODLE

YOUR PROPOSAL

Your proposal to a brand for sponsorship should be clear and concise. You have to put yourself in the shoes of the marketing manager and ask yourself what type of proposal would not only catch this person's attention, but would also look appealing. No approach is guaranteed, but I have found that having these elements will increase your chances of sponsorship:

- A clear introduction explaining who you are
- A paragraph or two explaining the art, project, or exhibit you wish to have sponsored
- A clear "ask" of the brand and how their sponsorship will benefit your art
- How enhancing your efforts will help the brand
- Supporting images and documents of the project

When making the initial contact, it is always best to write a personal paragraph to introduce the purpose of your contact, and then add the supporting proposal document. Remember, you are an artist, so keeping it warm and personal versus generic is best. Managers read corporate emails all day, so having a personal email from an artist that speaks highly of their brand sparks their curiosity.

SUPPORT FROM ANCESTRY.COM

My first big exhibit was called "They Still Lived," and it featured photographs of African Americans wearing African artifacts from an art collection. It also featured the results of DNA testing I conducted on all the participants who wore the artifacts. I didn't have to pay for any of the testing because Ancestry.com sponsored the exhibit and provided all the DNA kits, as well as a free subscription to their website. They also sent a film crew to do a profile about the project, and they wrote blog posts about the exhibit. The sponsorship was exhibit-specific and tied into their company's mission.

When I first started the project, Ancestry.com knew nothing about my exhibit. It was only after capturing a couple of photos of my first participant that I decided to reach out to Ancestry.com through Facebook, Twitter, and Instagram. I sent them the test shots, along with a couple of paragraphs explaining the details and goals of the project. I also described specifically how Ancestry.com could help support the project. A month later, they responded through Facebook with a request to set up a conference call. During the call, I explained the project in detail, and they were enthusiastic about how their product would be used to create art. When it comes to your practice and sponsorship, the main goal is to find common interests.

HOMEWORK

What brands are associated with the materials, tools, and topics used in your practice?

Research social media handles and marketing emails of the brand you want to work with.

What type of sponsorship do you see with this brand?

What type of benefit will the brand receive in exchange?

GRANTS

Grants are contributions by the government, or by an organization, for a specific purpose and to an eligible recipient. For an artist, this means you are able to apply for a grant to support your practice in a number of ways. The vast number of grants that are available means that there is a grant out there for everyone. Applications usually require a proposal for a project you want supported, or for research in a particular field of interest.

Applying for grants can be tedious and time consuming. One of the best ways to get comfortable with the grant proposal process is to just dive in. Become familiar with the rigorous hurdles of preparing things such as a proposed budget, a timeline, and a written report. After tackling a few grant applications, you'll start to become familiar with questions and other requirements that many grant applications have in common.

DON'T REINVENT THE WHEEL

Create a folder on your computer or an Internet storage service where you can save all your completed application answers. In many cases, grant applications will have similar questions. You can reuse parts of previous application answers on new grant applications when appropriate. Don't waste time writing the same answers to the same questions over and over.

LIST YOUR FAVORITES

There are so many grants that it's hard to keep up with which grants are the best fit for you. I strongly recommend you keep a list of your grants and regularly check up on them to make sure you're able to meet application deadlines.

DON'T GET DISCOURAGED

Remember, thousands of applicants are applying for the same grants. You will regularly get rejected for one reason or another, but don't let those rejections discourage you. There are many reasons why a grant proposal might be rejected. For example, a rejection could be because there was a highly competitive application pool or perhaps your application and work was similar to the previous artist awarded that grant and they wanted something different. Just remember that being awarded a grant isn't just about having a good application, as many other unknown factors must work in your favor.

HOMEWORK

To find online grant resources and databases, Google the following phrases and take note. Bookmark those sites that are most promising for you.

- Local city/state + grants for artists
- National Endowment for the Arts
- Americans for the Arts
- Art grant space
- Writing grants for artists

THOUGHTS ON GRANTS

- While you pursue grants, be sure to distinguish between demands of public funds vs. private, particularly in regard to your artistic freedom.

- In terms of time and energy, sometimes doing additional pickup work/having a second job is more dependable and has a more defined and predictable financial "return" than applying for grants, which can have a low odd of return.

- You can sometimes work trades with businesses or individuals in lieu of cash payments... but don't forget you'll need to claim this as income on your taxes.

Charles (Chuck) Parson, artist and professor

NOTABLE GRANTS TO RESEARCH

Aaron Siskind Foundation grant

Artadia Grant

Awesome Foundation Grant

Creative Capital Grant

Ford Foundation Grants

The Gottleib Foundation Individual Support Grant

Grantmakers in the Arts

The Guggenheim Foundation fellowship

The Harpo Foundation Grants for Visual Artists

Joan Mitchell Foundation Grant

Knight Foundation Grants

MacArthur Genius Grants

Pollock-Krasner Foundation Grants

ART AND CULTURAL DEPARTMENTS

Many governments have caught on to the fact that art plays a major role in the quality of life of their citizens. Because of this, you are sure to find a department in your local town, nearest big city, and state, that deals with advocating for the arts. Usually, these departments will have a title such as Arts and Culture Department or Arts Council. The titles vary from place to place, but Googling those titles, along with the name of the city or state will lead you in the right direction. In Denver, Colorado, where I currently live, the department is called Arts and Venues.

ARTS AND CULTURAL DEPARTMENTS ARE USUALLY FUNDED BY YOUR TAX DOLLARS, SO USE THEM. TAKE ADVANTAGE OF EVERYTHING THEY CAN OFFER.

These department will have programs, resources, workshops, and other opportunities to help you further your art career. I frequently look to these departments for funding opportunities, open calls for public art, lectures, networking events, and more. Get to know the individuals who run these departments because they are often the same people who make important art decisions for the city.

HELLO! I'M A LOCAL ARTIST AND I WANTED TO INQUIRE ABOUT THE DIFFERENT PROGRAMS AND OPPORTUNITIES THE DEPARTMENT OFFERS TO SUPPORT THE CREATIVE COMMUNITY...

YOUR GOOGLES

- (Your location) + arts council
- (Your location) + arts and business council
- (Your location) + arts and cultural department

NOTES 'N' DOODLE

CROWDFUNDING

Crowdfunding has allowed artists to take control of who, what, when, where, and how their projects are funded. Don't hesitate to ask for funds from people or organizations that support your work. You need to utilize the power and the reach of various platforms that can support your projects. Be careful, though! Because you have all the control, you bear all the risks and accountability of the funding campaign and execution of the project. Funders want to know that their funds are being put to good use.

CROWDFUNDING TIPS

HELP PEOPLE VISUALIZE VALUE

One of the cornerstones of a successful crowdfunding campaign is providing amazing visuals that communicate the value of the project. "Why the hell is your creative project important and what value does it provide?" Anything that helps people see that their funding will help add value to the creative world in a unique way will motivate them to champion the campaign. Professional videos, pictures, blogs, stories, and other content showcasing the details of the project create trust that you will need from potential supporters. You have to put yourself in a potential funder's shoes and ask yourself, "Is there enough information here that I can trust this artist and their artistic vision?"

BRING YOUR OWN CROWD (BYOC)

Many of the highly touted and successful campaigns on these crowdfunding sites are partially funded before they even launch, and this is because the creators bring their own crowd to the platforms. Don't rely on people stumbling onto your funding campaign and becoming supporters overnight. Marketing to and galvanizing your fan base (and well before the launch of a crowdfunding effort) will help ensure your project gets attention. You can easily introduce your fundraising campaign through your social media platforms to communicate the need for funding and why your project will bring value to the community.

> MARKETING TO AND GALVANIZING YOUR FAN BASE (AND WELL BEFORE THE LAUNCH OF A CROWDFUNDING EFFORT) WILL HELP TO ENSURE YOUR PROJECT GETS ATTENTION.

YOUR GOOGLES

- KickStarter art
- GoFundMe
- Indiegogo
- Patreon art

- Seed&Spark
- FotoFund
- Artist share crowdfunding

NOTES 'N' DOODLE

RESIDENCIES

Residencies provide creatives with a dedicated space within an organization, for a specified amount of time, to explore, create, research, and complete projects... within the context of that organization. Residencies are organized and established by organizations and foundations of all kinds, around the world.

Because of this, no residency is the same, so it is difficult to know exactly what resources a residency will or will not provide. Some residencies are paid, while others are not. Some are established and competitive to attend, while others are new and offer multiple spots. As an artist, you will be able to find residencies for just about any type of art form. Using research and networking, visual artists, writers, composers, choreographers, scholars, filmmakers, community artists, architects, and more can find a residency that fits them.

A great example of a residency would be the La Napoule artist-in-residency program that allows artists to live and work on the French Riviera in La Napoule, France, with several other artists from around the world. At the time of this writing, the program supports artists with a stipend, meals, living and studio space, and a dedicated staff to help explore the surrounding arts community.

SPREADING YOUR CREATIVE WINGS

Attending residencies helps build your résumé and demonstrates to others that you are dedicated to your craft, and that you are willing to experiment and explore outside your comfort zone. Selection committees love seeing that you're going for it, per se. Getting started in residencies is as easy as simply applying. Start with residencies that are less competitive and shorter in length. Become familiar with residency characteristics, such as having to create work in a new environment. Hopefully you'll learn how to quickly adapt your routine while trying to be creative in unfamiliar spaces.

Getting familiar with how residencies function allows you to take full advantage of a residency opportunity, especially when you're awarded one with amazing resources and support.

YOUR GOOGLES

- Artist-in-residence + (your location)
- Creative-in-residence + (your location)
- Residencies for + (your art form)
- Best-known residency programs
- Residency databases

- ArtistCommunities.org
- ResArtis.org
- Callforentries.com
- La Napoule + residency

HOMEWORK

What residencies could you find that you qualify for? Write down their information, such as the submission URL, application requirements, lengths, location, and deadlines.

Create a folder titled "Residency Applications," and subsequent folders with specific residencies, and start filling it with documents and materials you need to complete applications.

"Be careful to not get caught in (residencies) as effete art meccas or purely résumé-building steps. A danger to realistic artistic growth can occur in that kind of mindset."

Charles (Chuck) Parson, artist and professor

"It's basically a sacred space to help artists get enhanced visibility for their professional development, and to help foster their career. If you think about the difference between how visible an artist's practice is when their entire visibility to a community is on their shoulders, as opposed to stepping into a public institution that can amplify and network their practice to a broader community, that immediately increases their visibility to that community."

Louise Martorano, executive director, RedLine

JURIES AND COMMITTEES

Juries and committees are made up of a panel of one or more individuals convened to judge a pool of participating and sometimes nonparticipating applicants, using a subjective set of criteria that is dependent on the nature of the competition. Art juries are used to select the best fit for group art shows, gallery exhibitions, art fairs, residencies, schools programs, art fellowships, and more.

ANATOMY OF A JURY

Juries are usually put together by an individual or a group that is organizing the process to select creatives. These organizers will choose different people from the organization and the community to be on the jury panel. Member of the jury are experienced in many of the criteria that creatives will need to address in their applications. Some jurors may be former applicants/participants, while other jurors may be leaders in the local creative community. While there is no limit to the number of jurors on a panel, panels typically range from 5–10 people. Identities of jurors are often, but not always, kept secret until you make it to a possible interview phase; in some cases, you may never know the identities of the jurors.

Juries often change members with each cycle, in part to gather fresh perspectives from people with similar experiences. This makes each jury unique in its personality and how it scores applications. The same application that one jury may review would likely get a different score from another jury. The difference between being accepted or being rejected can come down to who is on the jury when you submit an application or portfolio.

ANATOMY OF A COMMITTEE

Committees are similar to juries, in that they are made up of individuals representing various backgrounds, with the expertise to help make decisions based on a particular criterion. However, a committee's composition changes less frequently than a jury panel. Individuals serving on committees may stay for multiple cycles to provide stability and consistency. In the art world, committees are responsible for reviewing exhibition proposals, shaping and planning events and conferences, selecting candidates for art programs, and more. A committee would not only work on reviewing submissions, but also seek out established artists to work with. Walk into any major museum and you'll see exhibitions that were the decision of the exhibition's committee for that institution.

Make it easy for juries and committees to get to know you. When applying, clearly articulate the context of your work and provide as much supporting material as they allow. Remember, committees sift through hundreds of applications, so the easier it is to get to know you and your work, the better.

QUESTIONS TO ASK YOURSELF

What are the merits that will be used to rate your application, and does your application address those concerns and areas?

Is your application easy to digest for the jury and committee?

How can you make your application easier to visually scan and quickly review?

Is your application as concise as possible? How can you make it more so?

Does the material you've showcased in your application provide strong visuals for jurors and committee members who may not know you and your work?

Do the portfolio items you're submitting in this application communicate your capabilities?

How can you further communicate that you can meet the requirements of the program or event?

WHERE COLLECTORS AND CREATORS MEET

"YOU NEED SOMEBODY WHO IS GOING TO TELL YOU THAT YES, YOU SHOULD CONSIDER THAT, AND THAT'S WHAT WE DO AS GALLERIES. WE ACTUALLY CREDIT THE WORK OF THE ARTISTS."

CHRISTINE PFISTER

GALLERIES

Think of private commercial galleries as a meeting place for collectors and creators. Private commercial galleries provide a place where artists can place their works and a place where they gather interested buyers to view those creations. Galleries serve an important purpose. Similar to a Walmart, or any retail store, private commercial galleries make it more efficient for artists to share their works with collectors who want to view and acquire art. Without galleries, artists would have to do the hard work of finding interested collectors to view their work in their studio, or in other places where they may hang. And if there were no galleries, collectors would have to take the time to find artists whose work they wish to acquire. The gallery is that space where both artists and collectors benefit.

GALLERIES AND THEIR TASTES

Galleries come in all different shapes and sizes. One size does not fit all. Galleries are as unique as fingerprints because people who take on the challenge of creating a marketplace for artists and collectors are, themselves, unique. To be efficient and unique, galleries focus on creating a market space that caters to particular collectors and creators. You'll find galleries that focus exclusively on abstract artists, on landscape artists, on conceptual artists, on blue chip artists, on emerging artists, on sound artists, on figurative artists, on light artists, on Black artists, on women artists, and on every other niche you can imagine. That approach is understandable because you can't be all things to all people, so focusing their tastes and efforts is what galleries do.

There are many benefits to working with a gallery, but make sure that you don't let the gallery owners or curators dominate your life or process.

YOUR GOOGLES

- Commercial gallery
- Consignment gallery
- Artist-run gallery
- Co-op gallery

- Vanity gallery
- Nonprofit gallery
- Blue chip gallery

NOTES 'N' DOODLE

SHOWROOMING

The role of today's galleries is now shifting to accommodate the changing habits of new and existing collectors. Doug Kacena, owner of K Contemporary Gallery in downtown Denver, explained that for many galleries, up to 80% of sales are coming from online buyers and originate all around the world. Many of those sales are to collectors who are familiar with an artist. These collectors may have seen the artist's work at art fairs, on Instagram, museum shows, or previous exhibits, and they've followed the artist for some time until deciding to pull the trigger on a piece they truly desired. In Doug's view, galleries are evolving to become international showrooms.

THE DECENTRALIZATION OF POWER

Before the Internet and especially before social media, galleries were the primary gatekeepers of the arts. Now, artists and galleries alike are cultivating the ability to connect with fans, collectors, and others across the world with a simple social media post. Although galleries are exploring how they fit into the digital age, they continue to hold a lot of power in that they are still seen as a reputable marketplace for art. Galleries forge and solidify relationships with museums, curators, fairs, and more. An artist alone would find it difficult to duplicate all the responsibilities that galleries take on. As an artist, do not disregard the role of galleries in the art ecosystem; instead, recognize and treat them as an added asset to your practice.

HOW GALLERIES FIND ARTISTS

Galleries are always on the hunt for fresh and innovative artists because they have to be ahead of the game. They can't just show the same artists and artwork that every other gallery in their niche shows. They are always on the lookout for artists they believe would be a good fit in their space. Some of the places that galleries seek these new artists are:

Exhibits in other galleries	Art fairs
Residencies	International press
Exhibits at universities	Regional publications
Exhibits in nonprofit spaces	Social media
Art biennials	Internet blogs and publications

YOUR GOOGLES

- (Your location) + art galleries
- New art gallery + (your location)
- (Your location) + group show
- (Your location) + art walk
- Tips on gallery representations

NOTES 'N' DOODLE

"Think of an appliance store. People come in and they look at a refrigerator. They open the door and say okay, this has all the stuff that I want. They then get on their phones and say 'Where can I get this in blue? Where can I get it cheaper?' I think people are introduced to the work through an art fair or through an exhibition, and then let's say the work that they were interested in was sold. They would look up that artist and find out what other works from that artist are available in different locations."

Doug Kacena, artist and K Contemporary Gallery owner

APPROACHING GALLERIES

Approaching galleries for representation means that you are looking for a place that will be your partner. Basically a marriage. This means you need to be able to trust the gallery you choose to represent you. Depending on the agreement, there could be exclusivity clauses that prevent you from selling work in a given area, or restrictions about taking on commissions without the gallery's approval. Choosing the right gallery for your situation is all about doing the right research and asking former and existing artists, as well as artist friends, about their experience with a given gallery.

FINDING THE PERFECT MATCH

Does your style fit in with the vision of the gallery? You won't truly know the answer to that question until you try to work your way in. One of the easiest ways to find out if your style meshes with the gallery's vision is to rip the Band-Aid off: call the gallery and ask how to submit work for its consideration. This method is far more effective than shot-gunning unsolicited materials in the mail. It is best to familiarize yourself with the gallery by researching the right person to contact and finding a common connection to the gallery, because you don't want to sound like a total stranger. Any relationship you can reference is good.

"HELLO, MY NAME IS THOMAS. I'M A LOCAL ARTIST. I'VE BEEN TO A COUPLE OF YOUR OPENINGS, AND I'M FRIENDS WITH TONYA, ONE OF YOUR REPRESENTED ARTISTS. SHE SUGGESTED I CALL YOU TO FIND OUT HOW TO SUBMIT ARTWORK FOR CONSIDERATION, AND ABOUT POSSIBLY SETTING UP A STUDIO VISIT WITH THE DIRECTOR."

HOMEWORK

After Googling many of the art galleries in your area, write down the names of galleries that fit your style. Dig deeper by doing further research on their submission processes.

Is there a common connection that you have with a desired gallery? Do you know anyone there who may be able facilitate an introduction?

What other galleries, in other cities, would be great for your work? Start Googling and keeping a spreadsheet of your findings.

How can you improve your work's visibility in your local area?

How can you improve the discoverability of your work for curators and gallerists?

How can you get your work into art fairs without going through a gallery?

This quick sample dialog demonstrates that the initial contact is really all about figuring out the best way to talk to the people at this gallery. If you're not a well-known artist, it takes a lot of legwork to get the attention you need and for galleries to start taking you seriously. Remember, it's a business, so their time is money and they don't want to waste it. Don't feel discouraged when you hear nothing back, or a "no" to your inquiry, because gallerists have a vision of their space and if your work doesn't fit that vision, representation probably wouldn't have worked anyway.

WORKING WITH GALLERIES

The sole purpose of a gallery representing you is for it to be your best advocate. The gallery, depending on the agreed responsibilities, should allow you to focus on creating rather than promoting; although, never forget that it is still important for you to promote yourself. Gallery representation should mean that it is hard at work representing your best needs to its entire network. The gallery should do everything in its power to find collectors and museums to acquire your work, fairs to promote your work, and opportunities for you to grow. Essentially, galleries should feel that your success is good for them.

Working with galleries is like any other business relationship and is similar to a partnership. Some galleries are more formal and involved than others, but this depends on the relationship. Many of the galleries I have worked with require very little paperwork, and most elements of our contracts and agreed-on responsibilities are verbal. In contrast, I have worked with some galleries where contracts are signed and everything is written up in an emailed document. As a business rule, it's always best to have a written contract for any situation.

NOTES 'N' DOODLE

ALTERNATIVE SPACES

Many artists mistakenly believe that the value of art is derived from the place where it hangs, or the publication it graces. Nowadays, this notion couldn't be further from the truth. Art that we appreciate now hangs on walls of nonprofits, restaurants, hotel lobbies, sides of buildings, regular homes, and various businesses. Art graces the front pages of community magazines and is featured in articles of online magazines and blogs. Your collectors, peers, fans, tribe, and supporters are all people who utilized spaces like every other individual. Why can't they appreciate art as completely in various other establishments and platforms the way they do in the well-lit exhibit halls of galleries and museums?

> ART ABSOLUTELY, UNEQUIVOCALLY, DOES NOT HAVE TO BE IN A GALLERY, OR ROLL OFF THE TONGUE OF A POPULAR CURATOR, FOR IT TO BE APPRECIATED AND CONSIDERED GOOD.

ADDING VALUE TO THE SPACE

When you're turning a space into a quasi-gallery, your relationship with the property's owners, managers, and staff is important. They shouldn't just see you as a feature that can easily be replaced with another artist. They should see your work as an integral part of the space. Through my own experience of finding alternative spaces, I understand how important a mutually beneficial relationship is. Align your motives (e.g., exposure or sales) with the motives of the space (e.g., decor, branding, or pleasing patrons). This leads to a mutual understanding of what actions both parties need to do to accomplish goals.

For artists looking to place work in any space, I suggest they focus on establishing a long-lasting presence. Unlike many galleries, where exhibits change monthly, artists that focus on having their work displayed on a quarterly, annually, or even on a permanent basis have the advantage of forging an intimate relationship with viewers. Viewers live with your creativity month after month, and see new works if you decide to rotate your art. It takes a lot of work to establish and maintain a smooth long-term relationship, and it requires constant communication to handle inquiries, taxes, shipping, rotations, payments, and so forth.

QUESTIONS TO ASK YOURSELF

What spaces in your area would work well with your style of work?

Does the space allow for your work to be presented the way you intend?

What space makes it easy for you to establish a relationship?

What are goals of the space, and will your art be appreciated by its patrons and management?

Will it be easy to communicate with management about your work in the space?

Would the staff be knowledgeable about your work when inquiries are made?

Do they have time and energy to support an artist adding work to the space?

Will the space allow for easy rotation of the artwork?

Will the space handle purchases, or will they refer potential buyers to you?

Will there be commission on sales?

Who will handle sales tax?

> *"Collectors and art lovers in general are taking in art wherever they go. And, with the number of galleries shrinking and online sales sites growing more and more challenging to sift through, nontraditional spaces can be an effective way to gain exposure."*
>
> **Justin Anthony**, Artwork Archive

MEADOWLARK KITCHEN – A MINI CASE STUDY

During my first year as a full-time artist, I asked to place my work in a restaurant named Meadowlark Kitchen, which is owned by a close friend. His restaurant was located on a popular corner of an up-and-coming neighborhood. I constantly rotated my art to keep the decor fresh for repeat customers. My work, like the food, quickly became a signature characteristic of the restaurant. Patrons became familiar with my style and they were able to watch as my work evolved. Meadowlark Kitchen became my unofficial gallery. "Where can I see your work?" "Well, you can eat at this restaurant and enjoy my work while you're eating." At the time of this writing, my work has graced the walls at Meadowlark Kitchen for five years. Countless opportunities and connections have originated just from patrons deciding to grab a bite to eat.

THINKING BEYOND THE WALLS

As you dive into looking for alternative spaces to place your work, remember that there are no rules. Don't limit yourself to coffee shops and clothing boutiques. There are many untapped spaces where your unique work will perfectly fit in. One idea that has been catching on is placing art in the set designs for movies, television, talk shows, and theater. These all require decor to set the mood of a scene, stage, or plot, so set designers spend considerable time looking for art that matches the mood they want to create.

A show that recently became a beacon for artists wanting to showcase their work is FOX's *Empire*. This television show, which features a family in the music business, displayed young contemporary artists in almost every scene. The writers of the show have even written the artist's name into certain scripts and plot lines. The current multimedia-rich era provides many new opportunities to find spaces where you can create your unofficial gallery.

YOUR GOOGLES

- Alternative spaces for art
- Art for set designers
- How to get artwork on television and movies
- Fox's *Empire* set design artwork

HOMEWORK

List 10 different stores, restaurants, venues, offices, boutiques, shows, festivals, and websites that prominently feature art. Then put on your investigator hat and start investigating how each entity makes decisions on art choices, and who is the decision maker.

> "We had the pleasure of creating musical art pieces at museums, art installations, schools, and universities. We get to write songs for television shows as well. We teach workshops about the power of creativity and just use music as one of our mediums. Collaborating with many artists through many mediums has expanded our creativity beyond the stage. We were artists-in-residence at Shangri-La in Hawaii, and we got to curate a museum tour. We also created a theme song for a cigar brand, and got to go to Nicaragua and experience the entire process of making cigars from seed to smoke. Creativity breeds creativity."
>
> **Aja and Samir** (The Reminders), musicians

THE ART OF ART FAIRS

Art fairs are, essentially, gatherings of galleries, advisors, collectors, curators, museums, and other art-related organizations for the specific purpose of talking about, looking at, consulting about, selling, and buying art. These fairs come in all shapes and sizes, and cater to various styles and demographics. Many art fair attendees want to stay current on the most cutting-edge artists and trends. Art fairs usually attract the "establishment" of the art world, because it usually requires some sort of payment to participate in an art fair. Sometimes, these costs can seem outrageous, but when you're at a great fair, it ends up being worth it. There's no other place to see some of the most exhilarating art up close and in one space.

As an artist, you should definitely take time to visit these fairs to soak up the collective energy. Going to art fairs allows you to see and experience some of the most prominent galleries in your area. If you decide to tackle a larger international fair, you'll see some of the most prominent international galleries – especially beneficial if you don't have the time and resources to visit these galleries outside the fair. You can see the stable of artists they represent, and how professional they are when representing their artists' works. These fairs provide an opportunity for working artists to take note of which galleries they may want to reach out to after the fair.

Because art fairs can be so expensive, many galleries can't afford to attend. This means that artists represented by galleries that *do* attend get even more exposure. This opportunity is something that many artists look into when deciding which galleries to approach for representation. Always ask, "Does your gallery attend art fairs and if so, which art fairs, and how often does the gallery attend them?"

SOME ART FAIRS TO LOOK INTO:

THE ARMORY SHOW	ART TORONTO	MATERIAL ART FAIR
ART BASEL	CONTEXT ART MIAMI	PARIS INTERNATIONALE
ART COLOGNE	COPENHAGEN ART WEEK	SCOPE ART SHOW
ART DUBAI	FRIEZE NEW YORK	TEFAF
ARTEBA	INDIA ART FAIR	VENICE BIENNALE
ARTRIO	LA ART SHOW	ZONA MACO

YOUR GOOGLES

• (Your location) + art fair

• Top art fairs to attend in + (current year)

HOMEWORK

Which art fairs are hosted in your area, and what galleries are exhibiting at those fairs?

Which large, international art fair can you attend that you haven't attended before?

Start making plans on attending at least one of these prominent art fairs. This will be an investment in your artistic growth and an opportunity to network.

After finding a large international art fair to attend, find out which gallery in your area is exhibiting. Begin making a connection with that gallery. It's always nice to have a friendly face to connect with while you both attend the international fair.

THE COLLECTORS

A collector is basically any individual who buys art. Whether they have one piece or a hundred pieces in their collection, collectors decided to give money in exchange for the expression of a creative. What does a typical collector look like? There're no two collectors that are the same, so treating collectors with a cookie-cutter approach just won't do. Collectors come in all ages, genders, income levels, and educational backgrounds, and they have different tastes. They all have different levels of collecting as well. Some collectors may have an extensive art collection built up over several decades, while others may be purchasing art for the first time.

MOTIVATIONS

Every collector has a different motive for collecting. Some collectors purchase art because it speaks to their preferred tastes – such as, abstract collages or the color red – while others purchase art because they see it as an investment and intend to sell it when the value of the work appreciates. Some collectors purchase work because it fits their home or office decor, and other collectors have an intimate connection with the artist's story.

COLLECTING ARTISTS

Before the early 2000s, having a window into an artist's life was difficult. Admirers didn't have access to the studio, thoughts, and personality of an artist whose work they enjoyed. Because of the Internet and social media, admirers have more access to an artist's personal life, ideas, thoughts, experiences, opinions, and more. They can engage with artists they enjoy and create experiences that go beyond the artist's work.

Create as deep a connection with collectors as possible. Your newsletters, social media, artist talks, collector dinners, and events should help others to become more familiar and comfortable with your practice. Don't be afraid to let people in and show them what makes you unique. We all have favorite authors, directors, actors, and musicians whose work we consume because we are invested in their creativity. Artists are no different.

NEW CROP OF COLLECTORS

There are now programs by cities, galleries, museums, and nonprofit and professional organizations that focus on developing new collectors. The programs teach potential collectors how to access art, artists, budgets, documentation, and more. New collectors are alway entering the art world, so it benefits you to start building a relationship with these new collectors and bring them into the fold of your practice.

"At some point collectors stop collecting art and start collecting artists.
So what that becomes is an artifact of an experience of knowing that artist.
It's not so much about the art itself but the memory of what it was."

Doug Kacena, artist and K Contemporary Gallery owner

ART CONSULTANTS

Have you ever seen a large painting in the middle of a bank lobby? Have you ever wondered how a high-end hotel has original art in every room and hallway? Well, 99% of that art is, most likely, there because of the efforts of an art consultant. Basically, an art consultant is the link between an artist and large organizations and institutions. Art consultants make their money by curating spaces that these organizations and institutions want to fill with art.

Art consultants serve as a vital conduit between the artist and the business. Let's face it, as an artist, the last thing you want, need, or desire is to put on a suit and meet with a corporate executive, shadowed by the regional manager, shadowed by their interior designers. Rather than sifting through paperwork and dozens of emails copied to countless other people, artists would rather focus on creating. And on the corporate side it's no different. Organizations and institutions know little to nothing about art. They would rather not have to spend time trying to discover and research the vast number of artists who are currently working. The people in these organizations would rather not face explaining the business jargon and their branding to every potential artist who may or may not work out – it's just not in their area of expertise. Art consultants are the people who can talk to the organizations' and institutions' decision makers, and get a sense of what to look for, stylistically, when searching for artists.

Rather than representing one or several artists, art consultants will have a database of dozens, if not hundreds, of artists they can call upon. Today, because there is a growing importance of art in public spaces, art consultancy is sometimes handled by specialized firms, with multiple people working on a given project. Many of these projects can surpass thousand-dollar budgets, and reach into the five and six figures. I know, that's a compelling number to factor into your creative budget, even if you only get to see half of it. This is because there is typically a 50% commission for the art consultant, which sounds high, but good consultants (much like great galleries) earn their cut by providing amazing opportunities for you to create and place your work.

As you grow your practice, consider working with art consultants. Because of the wide breadth of environments where consultants place art, there are opportunities for all forms of work. But don't get discouraged if you're not called upon frequently, because the client always makes the final decision.

Be aware that most corporate clients play it safe and steer away from work that may offend in any way, including politics, sex, and religion. These spaces are not in a museum. Because the audience will be people in a workplace, visitors who come through a hotel, or people who stay in an apartment complex or even a hospital, understand that no company wants anything that might generate bad press, or even a single pissed-off online review.

YOUR GOOGLES

• Art consultants + (your location)

• Top art consulting services in + (your location)

NOTES 'N' DOODLE

> "When you think about the role of a gallery, galleries occupy the space that connects artists to private collector and museums. But the big gap in that market that a lot of artists don't think about as an opportunity, is corporate collectors and corporate spaces. It could be a corporate office, lobby, hotel, apartment complex, hospital, you name it. Art consultants are working with a company who is a committed buyer because they need to fill a space with art within a given timeline. A hotel is not going to open up with empty walls."
>
> **Chris Roth**, curator, Nine Dot Arts

THE CURATOR

Curators specialize in exhibition building. They are like the herders of artists and objects, gathering them together based on a certain theme, topic, or criterion (e.g., artist's background, type of exhibition, or materials), or even on the type of audience they want to reach. If curators are good, decisions will reflect this. You might see scale models outlining where work will be placed, the venue will be carefully selected, and the best lighting will be mapped out and procured. In many respects, the exhibition they create is their art.

ANATOMY OF A CURATOR

Most accomplished curators who work with well-known artists have a degree(s) in studio art, art history, archaeology, museum studies, and other related fields. They gain experience by working in museums, galleries, and art centers that give them access to artists and their artworks. Curators gradually build a network of artists and resources for when they decide to venture out on their own. Although one doesn't necessarily need a formal education or museum experience to be a curator, it definitely doesn't hurt to have a background that can open one's perspective.

Today, with so many areas of the art world to focus on, artists themselves are actually taking the initiative and playing the role of curator. With the only requirement being a space to fill, artists are putting their relationships and resources to work and creating their own exhibitions with like-minded artists.

GET TO KNOW YOUR CURATORS

Get to know local curators so that when opportunities pop up for them, your work is in the consideration pile. All curators have their own style, tastes, favorite artists, and themes they like to work with, but they all love to be aware of the range of artists in the arts community. Making yourself known can be as simple as organizing a studio visit to talk about yourself and your work. For curators outside of your local area, a well-written letter can be all you need to get their attention. Sometimes all it takes is just a visit or an introductory letter for you to land on a curator's radar and start being considered for group shows and invite-only opportunities.

One of the best ways to find curators who might be interested in your practice is by researching some of the previous and upcoming exhibitions that you feel your work might suit. The curator's name is usually in the exhibition program, the marketing materials, or known by the gallery or museum staff.

HOMEWORK

List five curators in your city, state, country, or internationally who curate work similar to yours. Introduce yourself and your work with a personal note.

What artists can I invite to the next group show I'm curating?

IT'S NOT YOUR PARENTS' ART WORLD ANYMORE

"THE MOST IMPORTANT THING
YOU WILL EVER MARKET IS YOURSELF."

THOMAS "DETOUR" EVANS

ART MARKETING

I loved the line, "If you build it, they will come," from the movie *Field of Dreams*. As awesome as this concept is in movies, it doesn't reflect reality. If you make something, there's no guarantee anyone will see it. This is why marketing is important. In the digital age, with phones at our fingertips, everyone has the power to be a marketing powerhouse. Whether your goal is to market your work to sell, to get the attention of curators, or to create more opportunities in new establishments, marketing is needed. Until you have an assload of assistants or galleries doing all your marketing, you need to learn to showcase yourself. It's imperative that you become your best advocate.

Contrary to many beliefs, you don't need a marketing degree or some fancy social media–savvy marketing agency to get your work in front of people. Much of the knowledge you need can be found easily online and in marketing books. One of the most instrumental books that I've read and reread is *Purple Cow* by Seth Godin. There are also many other books, as well as podcasts that can give you a sense of direction on how to market yourself in the creative world.

RULES FOR THE DIGITAL AGE

REMEMBER, IT DOESN'T HAPPEN OVERNIGHT

Even in this microwave-fast society, success doesn't happen overnight. It will take several years, if not several decades, for an artist to feel somewhat successful in his or her level of exposure. Many of the most recognizable contemporary artists are in their 30s and 40s, and spent many years honing their craft and developing their style before the world took notice.

ART FIRST, MARKETING SECOND

Your art and practice MUST come first and foremost, and that will be the foundation of your marketing efforts. Without creating great art – unique art that has a purpose – your marketing efforts will fall flat. You may be able to garner attention, but without marketing, you will fall short in keeping a solid connection with the market.

"You *are the world's authority on* your *artwork.*"

Charles (Chuck) Parson, artist and professor

DON'T FOLLOW FOLLOWERS

It's easy to compare your exposure with other artists online. You see hundreds of thousands of followers that one artist may have and it makes you feel the need to do the same. DON'T!!! The number of followers an artist has doesn't mean shit! It's all about the quality of attention you garner that makes the difference. I would gladly trade millions of random followers (often made up of looky-loos and bots) for a thousand hardened supporters of my work and practice.

DON'T RELY SOLELY ON OTHERS

Don't rely on others to market you and your work. The best person to talk about you and your work is you! One of the changing dynamics today is that many opportunities are awarded to creatives who have built their own fan base. So don't expect to have a gallery, company, label (if you're a musician), or any other entity make you a household name. Just a few decades ago, this might have been the case, but today, the market is built around being able to create a one-on-one connection with the people it supports. Create your own email lists and your own online platforms to take control of your own message.

KEEP EXPECTATIONS REASONABLE

Your work will not appeal to 100% of the available market. Some styles, mediums, and subject matters are more marketable than others. There are even some galleries that pride themselves on dealing with hard-to-market works. What does this mean for you? It means you have to have reasonable expectations about the reach your work will have in certain demographics, locations, and platforms. Most importantly, this is not permission to shy away from marketing your work in certain areas, and it emphasizes the need for you to have reasonable expectations and to get creative with your marketing efforts.

THE MOST IMPORTANT THING YOU WILL EVER MARKET IS YOURSELF

Ultimately, collectors, museums, and other establishments are collecting *you*, just as much as they are collecting work you've created. Your ideas, your history, your personality, your message, your hopes, your dreams, your subject matter, your essence. Understanding how important this statement is takes time and experience. I always followed this idea but I took it to heart during my third year as a full-time artist. During that time, I repeatedly encountered people who sought me out because someone gave a positive recommendation of not only my work, but also my positive personality and work ethic. I understood that at the end of the day, my practice is more than just a creative product. It's the totality of me. They love the work but, even more, they truly love the mind behind the work.

NOTES 'N' DOODLE

TRADITIONAL MARKETING TACTICS

EMAIL NEWSLETTERS

As your career grows, you will be engaging with a wide demographic, and not everyone is going to be on social media. Even when they are, some will be on different platforms. However, most, if not all, will have email. Get in the habit of collecting emails and adding them to your email list. You should have people complete sign-up sheets at your studio and exhibits, as well as sign-up pop-ups on your website. Your newsletter should be a formal way of updating people about major projects, shows, and events that are happening in your practice. Mailchimp and Constant Contact are two of the largest email marketing applications you can easily use. Ask yourself the following questions:

How can I start to capture emails to add to my email list?

How can I make my email newsletter exciting to open?

How often should I send a newsletter update? Monthly? Quarterly?

PRESS RELEASES

Press releases are essential for formally contacting media publications about an upcoming projects, events, exhibits, or anything newsworthy that you may have in the future. You, like many others, may be tempted to shotgun your press releases to every media outlet possible. DON'T! These outlets get thousands of press releases like yours every day. Chances are slim that yours will actually get read, vetted, and make it on the news.

A better approach is to reduce the number of media outlets you approach to those whose audiences would truly find value in your message. Then, you should find the right contact and write a personal message addressing that person, and attaching a copy of your press release. The more personalized your message, the better. Put yourself in their shoes and imagine sifting through hundreds of cookie-cutter press releases. Personalized messages add a touch of humanity. Readers of your message can envision a person actually writing it.

In this social media era, emails are just one way of sending your press releases. Direct messaging outlets on social media have proven to be extremely beneficial. Although your direct messages need to be more personal than bot-like, you are still able to reach outlets directly – sometimes, even more effectively.

YOUR GOOGLES

EMAILS

- Mailchimp
- Constant Contact
- Email template ideas
- Email newsletters for creatives
- Newsletter ideas for creatives

PRESS RELEASES

- Sample press releases
- Sample press package
- Art news + (your location)
- Art bloggers + (your location)
- Art writers + (your location)

PRO TIP

Finding consistent media contacts who you can reach out to is extremely valuable. Whether they are bloggers, social media managers, reporters, news anchors, photojournalists, or critics, they are all people with whom you want to build a lasting relationship. To keep these contacts organized and updated, create a spreadsheet. It may make your media blitz for your next show much smoother.

HOMEWORK

Research a point-of-contact for each online outlet (e.g., online blogs, magazines forums, etc.) that are related to your art form and local outlets (e.g., news stations, newspapers, magazines, etc.) whose audiences can find value in your work.

Create an Excel spreadsheet with the following columns and add the contacts you have compiled from your media outlet research:

Name of outlet/publication:	Sample Magazine
Contact name:	Arty McArty
Contact position:	Assistant Editor
Email:	Arty@SampleMagazine.com
Website:	www.SampleMagazine.com
Social media handle:	IG @artyMcarty13

PRINT MATERIALS

Think about using traditional printed materials to reinforce the presence of your name, style, brand, look, and more. Just because it's the print medium doesn't mean it must seem traditional, though. Today, people are using print materials in creative ways. You can make your business cards from metal, or print your artist name on every shipping box you use.

With the number of local print shops and online print houses, you can find affordable print solutions for your needs. I listed some of these in the "Your Googles" section on the next page. Research which print materials work best for your practice and explore.

PRINTED MATERIALS TO CONSIDER FOR YOUR PRACTICE

Packaging materials
Business cards
Signage
Look books
Stationary

Invoices
Fliers
Postcards
Table covers
Banner envelopes

Calendars
Coasters
Apparel
Graphic wraps
Decals and stickers

GET CREATIVE

Although traditional marketing materials and tactics are common, that doesn't mean you can't get creative with your approach. You're an artist, so feel free to get creative and get weird. I regularly go on websites such as Pinterest to see what cool and interesting print marketing ideas I can add a twist to. Being an artist gives you the license to think of new and interesting ways of getting the word out about your art to the people.

One of my favorite artists is my friend Michael Roy, also known as Birdcap. In every composition that Birdcap illustrates, it seems there is a story to discover. The colorful characters he uses are all interesting and dynamic, which is why Birdcap regularly publishes small journal-sized comics that feature his work. These publications are like every other comic you can get in a comic shop – full of stimulating visuals and good storylines. This approach allows Birdcap to use the traditional print medium in an interesting way. New audiences become familiar with his style of illustration while enjoying stories.

YOUR GOOGLES

- Moo.com
- Overnight Prints.com
- Printful.com
- Smartpress.com

- Stickermule.com
- Uprinting.com
- Vistaprint.com

BIRDCAP

YOUR FAN BASE 101

FIND YOUR FAN BASE

In his book *Purple Cow*, author Seth Godin eloquently explains that when marketing, you should nurture and grow a specific community of people who will serve as the focal point for your marketing efforts. Godin referred to this audience as a tribe, and your tribe is, essentially, a community. We commonly refer to these people as fans. They share the same common interests (you and your work), and they share a common way to communicate (your platforms). You build your fan base to support your practice and distribute your work. Think of Beyoncé's fan club, the beyhive. The beyhive supports Beyoncé's work and practice. They communicate with Beyoncé and each other through various platforms and when a new song is released, the beyhive is the first to spread it through their network. This of course is the extreme, but it illustrates the point. Your fan base is the community that will share your work and information with their network, which may happen to be gallerists, curators, collectors, developers, city officials, directors, and other influential people.

I can't understate the importance of finding your fan base. These are the people who spread information about your work word-of-mouth, collect your work, share your work, come to your shows, and visit your studio. Focus on compiling their contact details and driving them to your platforms, so that together, your tribe can make a larger impact and you can focus your marketing efforts. Whether this platform is a Facebook fan page, Patreon, YouTube, Instagram, blog forums, Reddit, or some other new platform that comes out between me writing this and you reading it, you will need to have a place to allow your fan base to build and grow the community.

My fan base exists on social media – specifically, Instagram. I have curated the platform for members to feel free to interact with me and with other members in a healthy way. I engage with my fan base on a consistent basis by posting educational tips and giving advice on art. Through this community I have created, I've received many opportunities in the art industry.

PLACES TO FIND YOUR FAN BASE

Previous and current collectors

Engaged followers on social media

Studio visit attendees

Your exhibition attendees

Subscribers to your email list

HOMEWORK

How will you communicate with your fan base?

How will your fan base communicate with you?

How will the members of your community communicate with each other?

Are you a part of someone else's fan base? If so, what do you find effective about that base's communications? How can you apply these elements to your practice?

SOCIAL MEDIA

In the past decade, social media has been the most important disrupter in the arts community. There are no more gatekeepers to prevent you from showcasing your work. For artists and many others, social media increases awareness of the person *and* the art, solidifying loyalty among supporters, providing a soapbox for the message, forming community, and pursuing artistic opportunities. Social media can be challenging as well, and take time away from other areas of your life. Many artists shy away from social media because of all the noise and antics they associate with platforms; however, social media is only what you make of it. There are no requirements for how you need to act or present yourself. The main goal when using social media to showcase your art is to be your authentic self.

PICKING YOUR PLATFORMS

There are many platforms to choose from and they all require different types of content and approaches. Twitter is more text-based and opinionated, whereas Instagram is all about visuals. Picking the social media platforms where you should focus your time and efforts is important. You may be present on multiple platforms, but you should only have a few where you direct most of your attention. These platforms should:

be easy for you to start and maintain	be around long-term
allow you to create and upload content	connect with other platforms you use
communicate your work the way you want	allow you to easily communicate with your market
be popular with your market	

FIND YOUR VOICE AND CURATE YOUR CONTENT

When putting together your social media account, consciously decide how your account should look and feel. What's your message and how do you want to communicate it on your platform? If you look at some of your favorite artists on Instagram, you can see a consistent look, feel, and theme of their posts. The content you decide to create and post should be just as consistent. If your account is about your neon sign art, then posting unrelated content will add noise to your message. This doesn't mean that you're unable to diversify your posts, but remember that your postings should fit within your theme.

Artist Patrick Martinez's social media is about his studio practice, which revolves around social issues in the community. Therefore, when Patrick posts about political topics that focus on social justice issues, I am not thrown off or surprised because it fits his account's narrative.

YOUR GOOGLES

• Social media for artists + (current year) • Top social media platforms for artists

HOMEWORK

What is the top platform for your work? How easy is it to set up? How easy is it to maintain? Is your market using this platform?

Which will be your primary platforms and which will be your secondary platforms?

How will you incorporate the platform into your practice?

What story do you want to tell on your platform?

BE HUMAN. BE SOCIAL.

One of the biggest (and most ironic) mistakes you can make is to not be social on social media. Your platform is an opportunity to engage visitors to your account and to start a conversation about art. If curated correctly, you can gather opinions and feedback that may benefit the studio. It's entirely possible to learn about new techniques and materials through online conversations with someone halfway around the world. Engaging with your audience will build online relationships that transform into real-time progress and opportunities.

RESEARCH AND STATISTICS

Certain social media platforms have the added advantage of allowing you to see exactly what your demographic looks like and how these followers engage with your content. This may be diving deep into the weeds, but knowledge is power. Knowing where your audience is coming from and what people like most about your work will provide you with insight into your own practice and lead you to explore certain regions of the world for opportunities.

CONSISTENCY

Keep your presence on social media consistent. Whether you plan on posting and engaging once a day, once a week, or once a month, you need to keep your posts consistent and predictable. Building a schedule of when to post can help keep your platform current and active. It may serve you better to stockpile multiple posts and schedule them throughout a predefined timeline. Whatever you do, make sure you are able to keep a realistic and consistent posting schedule.

WHATEVER YOU DO, MAKE SURE YOU ARE ABLE TO KEEP A REALISTIC AND CONSISTENT POSTING SCHEDULE.

BE UNIQUE

Regardless of how consistent you are, or how well you know your audience, differentiating yourself from other artists will eventually give you a way to stand out in social media. The way you capture your work or process, or include your daily adventures in your posts, can help distinguish your account from others and garner you attention. Remember, out of the millions of profiles, what are you bringing to the conversation that other accounts aren't?

YOUR GOOGLES

- Social media management apps
- Hootsuite
- Social media analytical tools

- Best video editing apps
- Best time-lapse apps
- Best apps for creatives

HOMEWORK

Develop a social media posting schedule that you think you can reasonably keep.

Which social management application will help you schedule posts?

Search your current social media platforms for analytical tools that can help you understand your audience better.

Research some of your favorite artists on social media. What is the overall mood of their feed? What are they posting? How often do they post? How often do they engage with their audience?

WEBSITE

Your website is home to all your information. As social media platforms come and go, your website is a platform that you can completely control – the look, the feel, the content. To many viewers, it may be their first introduction to your practice. Your website will serve as a place for you to present important information, upload references, collect emails, send press, direct inquiries, post fliers, and more. There are many website content management systems (CMS) for you to choose from. Whichever CMS you decide to use, ensure that it makes it easy for you to build and maintain your own website without much support.

Your website should be an extension of your personality; therefore, don't just slap a website together without considering how you want visitor to see you. If you're not savvy with technology, no worries! Most popular website-building applications provide many examples of sites you can use as templates for your own. Regardless of which template you choose for structure, the content you use to fill your website should communicate you as an artist.

MAIN CONTENT

HOME PAGE

Your home page is the first thing visitors see, so it should communicate who you are and how to navigate the site to find more information about you.

ABOUT/BIO PAGE

This page should allow visitors to read more information about you and your work. Your bio and artist statement can live on this page, or on two separate pages.

PORTFOLIO PAGE

Your portfolio page or pages should separate your bodies of work. If necessary, a title, description, and/or image caption should accompany the different works you choose to publish. Don't feel the need to publish every work you have done. Only use your best works.

PRESS PAGE

List all the press you have received for your art. If there are many, choose the most relevant and the most prominent publications.

CV, OR RÉSUMÉ PAGE

Your CV page should host your CV. I suggest making information on this page brief and very easy to read.

CONTACT PAGE

Provide a way for visitors to easily contact you. Most professional connections will go through your official email, rather than social media. Make sure your contact form is working. Sometimes, glitches may happen and prevent you from receiving inquiries.

YOUR GOOGLES

- Popular CMS
- Squarespace
- Wordpress
- Wix
- Weebly

ARTISTS WITH UNIQUE AND INSPIRING WEBSITES

- Tauba Auerbach
- Banksy
- Alex Binnie
- D*Face Artist
- Wim Delvoye
- Dufala Brothers
- MadC Artist
- Swoon Artist
- James Turrell

BEST PRACTICES – THE DOs AND DON'Ts

Do make a site that's easy to update.

Do keep menu options to a minimum.

Do add a detailed caption to images.

Do separate bodies of work.

Do make your website mobile friendly.

Do link your website to your social media.

Do invest in photography of your work.

Do check grammar and spelling.

Don't use oversized photos.

Don't leave dead links up.

Don't complicate your site's navigation.

Don't publish empty/underwhelming pages.

Don't publish unrelated content.

Don't add glitchy plug-ins or apps.

HOMEWORK QUESTIONS

What CMS do other artists in your community use? It's always helpful to get firsthand reviews.

Do you need an e-commerce system on your site? What other features do you need to have?

How much should you allocate to your website budget?

Which domain names are available for you to choose from?

What mood do you want your website to have?

RELATIONSHIP BUILDING FOR CREATIVES

Networking for artists or, as I like to call it, relationship building, is all about being as much a part of the community as possible. It's *not* about crawling through every gallery or opening with your business cards and portfolio. It *is* about creating and nurturing relationships in the community. Many of your opportunities will come through the relationships you build, and I can't emphasize this point enough. The people you build relationships with will eventually find themselves in decision-making positions – curator, creative director, gallery management, board member, juror, intern, business owner, and many other roles.

The more you nurture these relationships, the more opportunities will come your way.

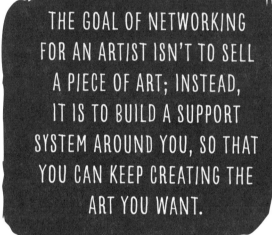

THE GOAL OF NETWORKING FOR AN ARTIST ISN'T TO SELL A PIECE OF ART; INSTEAD, IT IS TO BUILD A SUPPORT SYSTEM AROUND YOU, SO THAT YOU CAN KEEP CREATING THE ART YOU WANT.

BE GENUINE

The most important part of relationship building is being genuine. Nothing is worse than a transactional relationship. Transactional relationships neither last long-term, nor are they healthy. Relationships that are genuine are grounded in the idea that you care and want the best for the other individual.

GETTING INTO THE KNOW

One of the questions I'm asked most often is, "How do I get connected to the artist community?" The answer boils down to two simple things. First, be present. Second, contribute. Being present means consistently attending various activities within the artist communities. As I write this section of the book, my neighborhood's art district is about to host its annual meeting, which I plan to attend. Being consistently present at these events, as well as at gallery openings, artists' talks, workshops, lectures, festivals, and other gatherings, increases opportunities for serendipity. I can't tell you how many times I had to drag myself to an event that later resulted in a meaningful connection with someone new.

YOUR GOOGLES

- CreativeMornings
- (Your location) + art meetup
- (Your location) + startup week
- (Your location) + art center

- (Your location) + art week
- Adobe conference
- (Your particular medium) + conference

"I've been living in Long Beach for four years. When I first moved out here it wasn't really strong. I had never been a part of an artist community and I wanted to create some type of culture. That was just me thinking out loud and telling people. It came true. I would start going to art walks and participate in them and eventually people started recognizing (me), and I started seeing other artists' work ethics, and I would be like, 'I can mess with this person and this person is really cool' – and it was vice versa.

"I'm now a part of Hello Welcome. That's our art community at Long Beach. It happed very naturally. I'd meet one artist and this other artist had met me before. We all kind of knew each other and eventually we were like, let's all hang out. We got together and that's how our community happened. It's called Hello Welcome. And now, once you're in an art community and they have helped you do murals, (and) you helped them do murals, they can come to you for help with something they're working on and vice versa – that's priceless. Just to be around another artist that feels your pain, feels what it is to be weird, feels what it is to be alone when you produce your artwork. You need that. It makes you feel like you're not alone, like you're not the only crazy person out there."

Juan "Joon" Alvarado, artist and illustrator

135

CONTRIBUTE

To contribute means to add value to the community. Whether contributing is done in the form of volunteering, helping to organize and plan events, starting workshops, or participating in other activities that benefit the community, contributing is always appreciated and noticed. A desire to meet other creatives led Tina Roth Eisenberg to start New York City's CreativeMornings, using one small meeting. Now, these monthly meetings are hosted globally and attract thousands of like-minded individuals. Tina contributed by creating a space for the community to meet. By contributing, you'll become familiar with movers and shakers in the community and learn how those relationships work. The more you're present and contributing to the community, the more you are noticed and embraced. It takes time and there are no shortcuts. Just be present, contribute, and be patient.

GIVE MORE THAN YOU TAKE

Relationships that are one-sided sow seeds of resentment and frustration. Artists (well, everyone actually) should focus on giving more than they take. When you have a genuine relationship, you should feel the need to help others whenever and wherever you can. My relationship with the greater arts community is just that. I provide Art Tip Tuesdays every week, even though it comes at the cost of time and resources. I feel the need to help other artists, just as much as I have been helped. This attitude breeds a reciprocal, positive, and healthy relationship within communities.

BUDDY SYSTEM

Introverts such as myself might experience anxiety when we're in social places and alone. Not knowing what to say to start a conversation, we may act and sound a little awkward because we're nervous about being judged. "What the hell do I say to make a meaningful connection?" When in those types of situations, I began to notice that when I was accompanied by a friend, or friends, my anxiety vanished. Having someone who helps to start and hold a conversation can make all the difference. The anxiety washes away and you will quickly begin to feel comfortable in your own skin. You will find that you become very comfortable just being yourself, in part, because you have support next to you.

HOMEWORK

List some of the establishments that frequently host creative events and start plugging these events into your calendar.

Pull together a list of friends you would be able to use to create a buddy system. Talk to your friends about accompanying you to openings, fairs, exhibits, museums, festivals, retreats, workshops, and other creative events.

Get in the habit of talking about yourself and your work. List some of the major talking points and terms that really describes the nucleus of why you create the work you do.

ELEVATOR PITCH

Most of us have seen the television show *Shark Tank*, where entrepreneurs go before a panel of investors and make a pitch about their business and themselves. No need to panic, I'm not saying you need to go on television to pursue investors – I'm just suggesting you craft a precanned pitch you can regurgitate whenever you need to. You should always be able to fully explain your work, yourself, your techniques, your purpose, and everything else about your practice when prompted with questions. Easy, right? Well, it might not be easy, but it is necessary, because few things in building a business are more traumatic than being asked about your work and finding yourself unable to quickly respond with a clear and passionate answer.

KEEPING CONTACTS

Keep contacts of everyone you can. Why? Because you never know if and when you may need to reach out to them for one reason or another. A web developer who you spoke to at an opening of a play may just be the person you can bring in to help when you're programming an installation.

CHECK YOUR EGO AT THE DOOR

It's easy to feel full of yourself when everything is going right and you have momentum on your side. However, this can lead to the perception of being selfish and difficult to work with. Regardless of who you meet, you want them to leave the encounter feeling better about themselves after talking to you. Give everyone the same respect, regardless of any biased perceptions and stereotypes. We all have them, even if subconsciously. Many times the people you least expect to surprise you are the ones who are the most supportive of your practice.

THE
BUSINESS
OF ART

"BEING GOOD IN BUSINESS
IS THE MOST FASCINATING KIND OF ART.
MAKING MONEY IS ART AND WORKING IS ART
AND GOOD BUSINESS IS THE BEST ART."

ANDY WARHOL

PRICING

The pricing conundrum is one of the hardest issues artists navigate. Am I pricing too high? Am I pricing too low? Did I give myself enough room to negotiate? These questions run through an artist's mind when trying to decide price. The simple answer is, there is no standard way to price art. No equation, nor formula, can determine the perfect price point for your work.

PSYCHOLOGY OF PRICING

Pricing can tell potential buyers a lot about the work. Price your work too low, and buyers may see less value in the work because they see the two as directly related. The low price may also make buyers feel that the work is too attainable. "Why would I buy it if everyone can buy it? It's not special." Price your work too high and you run the risk of turning off buyers. They may see you as arrogant or delusional. With a reasonable price point, buyers place value on your work and respect it. I have noticed that creating an authentic connection between the buyer, the artist, and the work, is what really drives value. The more connected a potential buyer is to your story, background, process, message, artistic concepts, philosophy, and outlook on life, the more value they place on your work.

SOME RULES TO CONSIDER

RESPECT YOUR WORK

Don't let others knock down the value of your work by offering far less than your asking price. You have to be willing to walk away from an offer or a commission that undervalues your work. Even if it is the only offer available, don't ever feel that need to have to sell.

DON'T BE YOUR BEST COLLECTOR

Some may get accustomed to growing too close to their own work. As an artist, you have to be able to let go and share the work you created with the public. Create, share, create, share, and then create some more.

BE PATIENT

Your work is not the latest pair of sneakers coming off the factory line, so don't get accustomed to lowering prices just because it didn't sell as fast as you wanted. Sometimes, it take weeks, months, and in some cases, years, for the right buyer to come along and see the same value in your work that you do.

"I think it's hard as an artist to time yourself and fully determine how much time it is taking me to sit down and do this. And then there's the price associated with the idea as well, and me getting comfortable with the idea that it's my vision and my skill set that I'm lending to the piece. So [I need] to factor all those pieces into it rather than [just] going by materials and time. I have an easier time doing that with retail products, but when it's a one-of-a-kind piece that I'm making, it's a little trickier."

Becky Wareing Steele, miniature artist

"[Pricing for] my studio work really depends. It depends on the style I painted it in and the years. I tend to price my older studio work higher than the newer stuff. I guess a sense of nostalgia begins to build up. Also the studio work is priced based on previous sold works in that same size and style. Current market values for comparable works from other artists come into play as well."

Luis Valle, artist and muralist

FACTORS TO HELP YOU PRICE YOUR WORK

PREVIOUS SALES: Past sales are great predictors of what the market can bear. Use your sales history to help set future price points that are reasonable.

SIZE: Size is an important factor because typically the larger the size of the work, the more logistics, resources, and time are needed to complete it. Make sure you consider the added costs of things such as transportation and shipping that may be required.

INVESTMENT: How much time, money, resources, and labor did you invest in the work? The cost associated with creating the work is important because you need to recoup those expenses so that you are able to continue creating without losing much-needed funds.

CAREER STATUS: How established is your art career? An artist who is just starting to exhibit work is new to collectors as well. Their work, as opposed to that of well-known and established artists, may consequently be priced lower than desired until the market becomes familiar with the work and the artist's career trajectory.

DEMAND: Is there a demand for your work? As an artist's career and exposure grow, the higher the demand for their work will be. The higher demand allows an artist to charge higher prices for their work.

EXCLUSIVITY: Is the work an original, or is it a part of a collection? Works that are more exclusive are more desired. Works that are originals, or part of a limited edition, should be priced higher than works that are copies or are widely available.

ENVIRONMENT: In what types of places are you exhibiting your work? The environment where you display should influence the price point you set.

COMMISSIONS AND FEES: Is there a commission or transaction fee involved? Sometimes there is a commission or fee the gallery, fair, agent, or establishment collects when art sells. Your price should account for any additional costs that will be accrued if your work sells.

YOUR HOMEWORK

The best information comes from insight. Visit all the establishments that sell creative works in your local area. Record the pricing you see, including the artist's name, a description of their works, and listed prices for the artist's works.

Ask the establishment about the artist and the sales of the artist's work.

Do some online research about the artist and her/his work. Can you glean any insight into how the artist determined those prices for the work?

Saatchi.com and Artsy are leading online art markets. Browse various categories and view the prices that artists give their work. Write down all the insight you gain from your research.

"Some thoughts on pricing:
1. It's much easier to raise your prices than to lower them.
2. Make many comparisons to determine established
market value for your type of art.
3. Be ethical, and do not undermine a gallery, consultant,
or curator if they are involved and a client comes directly to you."

Charles (Chuck) Parson, artist and professor

COMMISSIONS

EDUCATE YOUR CLIENTS

You will be approached by many potential clients. Some have commissioned work before and some have not. You'll need to bring new clients up to speed on your commission process and agree on expectations for the final piece. Inform them of your dos and don'ts, as well as limitations (think of an abstract painter being commissioned to paint a mural depicting a group of kids playing on a playground). When taking on a commission, I always ask clients if they are comfortable with my style and interpretation. Ensuring that you both are on the same page is the basis of a good commission experience.

COLLECTING PAYMENT

The payment process should be established at the beginning of any commission discussions. Having a clear payment process will help clarify how you will be compensated and when. My process is very different for different individuals, and is based on my familiarity with them. I don't want to feel robotic and rigid with trusted collectors, and I don't want to be too trusting with people I don't know. I also want to protect myself in situations such as when a client is unresponsive or MIA (missing in action) in the middle of a commission. Establishing and getting comfortable with your practice's payment structure takes time, but to get started, here are some of the common payment structures you can consider:

HALF NOW, HALF LATER: Recommended for new clients and large work that needs supplies and materials to complete. Very common when working with big brands and governmental departments.

FULL PAYMENT UP FRONT: Recommended for new clients who you don't know well, and for clients commissioning affordable works.

FULL PAYMENT ON DELIVERY: Recommended for loyal clients who you are familiar with, and for clients commissioning moderately priced works.

STRUCTURED PAYMENT PLAN: Recommended for high-priced commissions ordered by established clients. These payments can be split evenly over a number of months that are set out in the agreement.

TRADE ON DELIVERY: Recommended for clients who provide services you need. Legal, fabrication, and printing are all services I have traded work for.

HOMEWORK

Use these questions as a prompt for negotiating any commissions you are contemplating. Before meeting with the client, list any other questions you feel are important to you and that must be addressed to ensure that a commission is worth taking on.

Is the client new to commissioning work?

Is the client familiar with your work and process?

Can you meet face-to-face with the client?

Are you clear in communicating your dos and don'ts?

Is the client's commission achievable?

Do you have creative freedom?

Does this creativity add value to your practice?

Is this commission a good use of your time?

What is the time frame of the due date?

How much time and how many resources will you need to complete the commission?

How will the work be delivered? Picked up, or will it need to ship?

What type of payment structure is best for this commission?

How will you get paid? Cash? Check? Credit card? And is there a transaction fee?

PROCESS STAGES

During a commission, you'll go through different stages of your creative processes. From ideation to the final work, establish what these stages look like and how they will involve the client. Are there going to be drafts or mock-ups? If so, how many? You don't want to end up in an endless cycle of revisions and drafts, so be as clear as possible with the client about how different stages of your process will work.

COMMUNICATIONS

Establishing a clear form of communication is critically important, especially given that you will not be face-to-face with many of those potential clients. Being commissioned through social media is fairly common, so protect yourself by being as straightforward as possible throughout the process. In 2018, California real estate developers commissioned me to create a mural on a building they bought in Denver. All communications were through email. However, some miscommunication happened. We both made assumptions about whether there should be a protective coating covering the mural, and who would be responsible for the costs. In the end, we both read through the previous emails and saw where we'd each made wrong assumptions. Keeping good documentation allowed us to resolve the issue without legal action. We ended up splitting the cost because we saw where we were both at fault.

> THERE'S NO MAGIC PROCESS TO GUARANTEE A SMOOTH COMMISSION BECAUSE EVERY COMMISSION IS DIFFERENT. YOU'LL NEED TO BREAK SOME OF YOUR OWN RULES AND BE PREPARED TO ADJUST TO CHALLENGES BECAUSE CLIENTS WILL ALWAYS THROW YOU A CURVEBALL.

CREATIVE FREEDOM

Creative freedom is of the utmost importance. You must be willing to turn down a commission if taking it on would harm your creativity and practice. Just don't do it. You don't want to regret working on a commission that you resented. When you have creative freedom, you are able to comfortably create, without the pressure of limitation. You want clients to hire you for your creativity, rather than your ability to execute a plan.

NOTES 'N' DOODLE

"Everyone that I work with, no matter [if they're] collectors or new commissions, gets me at my core. I value anyone who values my work. It's just that simple. I haven't given up any creative freedom, and most people I've been lucky enough to work with have not asked me to give up any creative freedom. They simply allow me to do my thing! Currently, I am not restricting any types of commissions. I love what I do, so when I get a chance to do it, I just want to do the best work."

Rob Hill, visual artist, fashion designer

"Our commercial projects have freedom so at the end we are doing them for passion. If not, we will not do them. We believe in the freedom of the artist. We find the perfect balance in projects before we accept them."

PichiAvo, artist and muralist duo

NEGOTIATING

As an artist growing your practice, you will find yourself in many situations that require negotiation. Artists think this means dealing with pricing, but you'll encounter situations where negotiating means talking to galleries and museums, taking on commissions, getting sponsorships, working with big brands and nonprofits, and even when exhibiting at the local coffee shop.

TIPS FOR NEGOTIATING

BARGAINING ZONE

Create a bargaining zone that allows you room to negotiate. This is a range between demanding exactly what you want in compensation and settling for your bare minimum wants and needs.

GAIN INFORMATION TO UNDERSTAND OBJECTIVES

Both parties should feel as if they gained something. Learn as much as possible about the other party to understand their objectives.

BE WILLING TO WALK AWAY

If you're not willing to walk away, you're not negotiating. It's hard to do when you're not used to negotiating, but it will keep you from getting into deals that hurt your creative freedom.

WANTS VS. NEEDS

Knowing the difference between your wants and needs will help you determine items in an offer that you can concede on, and items in an offer that are a must-have.

REMOVE YOUR EGO

Don't think of negotiation as a competition. Think of negotiations as a win/win opportunity, where both parties are benefiting. So don't try to squeeze the other party out of everything they have, even if possible.

JUST ASK

Don't be afraid to ask for items, services, or conditions that benefit your comfort level. The worst that can happen is that the other party says no. It never hurts to ask.

ONGOING RELATIONSHIP

Remember that many of the negotiations you're doing will be with parties with whom you will have an ongoing relationship. You have to be able to make deals that make both parties happy so that both sides want to continue the relationship.

NOTES 'N' DOODLE

CONTRACTS

As your art career grows, you will be asked to sign contracts that come in many forms. Artist agreements, leasing agreements, release forms, licensing and copyright agreements, partnerships, insurance, and more will be thrown at you at some point. These contracts should protect the interest of all parties involved, are instrumental in preventing many issues and in resolving disputes and confusion, and will be a vital part of your practice. Contracts can be verbal, or even better, recorded digitally or on paper. Always keep a record of the agreement stored in a safe place.

CONTRACT ADVICE FROM ONE ARTIST TO ANOTHER

READ EVERYTHING

It's important that you read and understand contracts. Never assume anything. Certain contracts, for example, may prevent an artist from working with other galleries or agents, prevent them from selling work above or below a certain price, demand exclusivity of an artist's work, or even demand that you post work on your social media. These and many other obligations can be buried in contracts that are several pages long. Signing a contract indicates that you've read and understood it and therefore it binds you to the agreement within it.

FIND A LAWYER

The smartest thing you can do is to have a lawyer read a contract and translate it into simple terms for you. This service can cost money, but there are several lawyer-based organizations that provide artists with legal services for free or at a discount. Building a relationship with a trusted individual who understands law can greatly assist your career, because this professional should truly represent your best interests, and can advise you on what else you can do to protect your practice.

ASK AROUND

Get in the habit of asking other artists about their experiences working with the party you are about to enter a contract with. Artists do not shy away from sharing horrible experiences of working with galleries, curators, agents, big brands, and collectors. Just because there is a contract, it doesn't mean you can't have problems. Avoid any potential stress up front if you can and save your energy for the studio.

DON'T BE AFRAID TO USE LEVERAGE IN NEGOTIATIONS

I have signed hundreds of contracts. Each contract is different because my leverage, or power to negotiate, is different. Don't be afraid to use your leverage to ensure your best interests. This can range from requiring galleries to get insurance when loaning your work, or restricting whether your work can be used in photographs or advertising. There are many items you can add to a contract. Just because you're presented with a contract doesn't mean you can't amend it and negotiate to make it beneficial for all parties involved.

YOUR GOOGLES

• Legal services for artists + (your location)

• LegalZoom + art

• Nonprofit lawyers for artists

• Nonprofit accountants for artists

HOMEWORK

List all local legal organizations that focus on providing artist-related law advice and services.

Ask fellow artists, arts organizations, and even professors for the names and contact information for lawyers who work specifically with the creative community. Keep these contacts on a spread sheet and start building a contact list that you can rely on when you need legal help.

SHIPPING CREATIVE ITEMS

COURIERS

When your work starts selling outside of your local area, you'll need to find a courier that fits your shippings needs. Not all couriers are the same, so research how your work fits within their services. Understand the cost of shipping your work up front because this will impact your decisions about exhibiting your work in certain places, whether to participate in group shows, and whether to ship internationally. These decision become harder when the cost of shipping your work exceeds the dollar value you assigned to your work.

If you are in the habit of shipping works multiple times a week, it may benefit you to open a shipping account with your preferred courier. These accounts allow you to smoothly create shipping labels so you can ship from your home, or from your studio.

ART SHIPPERS

At some point when your work becomes too valuable or too large to leave with a standard courier, you'll need to turn to professional art craters and shippers. These companies, which specialize in regions, pack and ship for galleries, museums, companies, and well-to-do clients. They can access your work and analyze the best shipping and transit solutions. Finding an art shipper to ship to your destination location is as simple as searching the phrase "art shippers (insert location)."

PACKAGING

Whenever you're transporting your creative work, there are two basic packaging options that will protect the work while it's in transit. The first is to have the courier package your creative work for you. Couriers such as FedEx and UPS provide this option for an additional fee. Usually, this option comes with insurance built into the overall costs. The second option is packaging your work yourself, but this requires more time and resources. If you frequently ship work of the same size and shape, this option may be preferable because you save money by purchasing packaging material in bulk, without the fear of creating costly waste.

INSURING

The more facilities your package goes through, the more likely it is to be mishandled or lost – especially when shipping internationally. Having insurance helps when trying to recover your losses from damaged items or lost packages. Get into the habit of insuring your work. Many carriers insure works valued up to $100 for free. Any amount over will cost extra.

YOUR GOOGLES

- (Your location) + box company
- www.Uline.com
- Amazon.com art packaging materials
- FedEx + (your location)

- UPS + (your location)
- USPS + (your location)
- DHL + (your location)

HOMEWORK

Research some of the common and uncommon packing materials to understand how they can benefit your shipping process if you decide to self-package. You can easily obtain these materials and more through establishments such as UPS, FedEx, your local mail carrier, box companies, and online stores such as Amazon.

Packing tape	Felt
Masking tape or blue painter's tape	Ethafoam
Plywood and masonite	Cellulose wadding
Plastic sheeting or bags	Bubble wrap
Glassine	Fine excelsior
Gatorfoam/Gatorboard	Crinkle paper
Volara	Chipboard pads
Foam popcorn, chips, or peanuts	Packing paper
Foam core	Corrugated cardboard roll

"When shipping, see if you can take advantage of your support network to combine shipments. Who else is traveling there? Who else will be showing there? Consider business-shipping trades, as well."

Charles (Chuck) Parson, artist and professor

BUSINESS: IT'S TIME TO GROW UP!

As an artist, you need to understand how to navigate the business world. First things first: decide what your classification should be. Some of the most common entities that artists form when working and paying taxes (in the United States) are sole proprietorships, partnerships, and limited liability companies.

SO, WHAT'S BEST FOR AN ARTIST?

If you're trying to decide what sort of business classification will suit your work, it's worth taking the time to explore the details of the various options, because the best choice for you will depend on several factors. The type, scale, and nature of the work you will be creating, in addition to the size of your practice, will make a big difference with the entity that best suits you. From experience, I started out as a sole proprietor, because I didn't have much activity other than making art – I didn't have big clients and I was barely making a penny. After gaining momentum and actually selling a significant amount of art, my accountant switched me to an LLC. The more activity that flows through your practice, the greater the issues that can arise – taxes, liability, scaling-up my practice, and dealing with the government, to name a few. There is a lot more work involved in forming and maintaining an LLC, but there are several benefits to doing so. Talk to an accountant and a legal professional to see what works best for the current stage of your practice.

YOUR GOOGLES

- Setting up a sole proprietorship in + (your location)
- Setting up a partnerships in + (your location)
- Setting up an LLC in + (your location)
- Set up a business bank account with + (preferred bank)

- EIN for artists
- Business credit card for artists
- Online accounting system for small businesses
- Accountant services for artist in + (your location)

SOLE PROPRIETORSHIPS

Owner remains personally liable for lawsuits filed against the business.

No state filing is required to form a sole proprietorship.

Owner reports business profit and loss on personal tax return.

PARTNERSHIPS

Partners remain personally liable for lawsuits filed against the business.

Usually, no state filing is required to form a partnership.

Partnerships are easy to form and operate.

Owners report their share of profit and loss in the company on personal tax returns.

LIMITED LIABILITY COMPANIES (LLC)

Formed to limit liability for lawsuits filed against the business.

Independent legal structures are separate from company owners.

Designed to help separate personal assets from business debts.

If one owner, taxed similarly to a sole proprietorship; for multiple owners the tax structure is more like that of a partnership.

There is an option to be taxed as an S-corporation.

No limit to the number of owners.

Able to use an employer identification number (EIN) on W-9 forms and other tax documents.

BENEFITS OF LLC

LIMITED LIABILITY

One of the best features of an LLC is that it protects you personally from lawsuits filed against the business. Should you hire employees, work in public art, and deal with clients and businesses, this can be important if you're ever served with a lawsuit due to work you did or did not do (e.g., a sculpture falls on someone). With limited liability, individuals can only come after your business finances and not your personal finances. There are exceptions, so talk to a legal professional to learn about any potential liabilities your business might face.

ABILITY TO WORK BUSINESS-TO-BUSINESS

Some business, such as wholesalers, only work with other businesses and not consumers, and you'll want to get all the discounts and access to wholesale-priced supplies you can. Your business's employer identification number (EIN) will enable you to work with many manufacturers vs. being a regular end-consumer.

SEPARATION OF PERSONAL AND BUSINESS MATTERS

The EIN you receive when you start a business is like your business's social security number. You use the EIN for tax purposes and to open up a business bank account. Having an EIN allows others access to business financial information and statements, as opposed to your personal information; it's very helpful in preventing identity theft.

ACCOUNTING AND TAXES (CHECK LOCALLY WITH AN ACCOUNTANT)

This will vary county to county and from state to state and even city to city. Each entity (sole proprietorship, partnership, LLC) will handle cashflow differently and will thus be taxed differently. For example, many artists have to pay self-employment tax, which is basically social security and Medicare tax. Usually, if you were working a regular job an employer would pay half of this tax, but as a self-employed artist, you have to pay the entire amount.

In many states, if your business is a sole proprietorship or an LLC, you'll need to complete an IRS Schedule C to account for your business's profits and losses. This helps separate your taxes from your art business and helps reduce your self-employment taxes due. True, it requires a lot more paperwork and time, but the savings during tax season are great. While this may seem boring or confusing, understanding your accounting and taxes will certainly save you time, money, and headaches in the future.

NOTES 'N' DOODLE

SEPARATING YOUR FINANCES

One of the best decisions I ever made was to get my financial house in order by separating my personal finances from my art-related finances, and I highly recommend you make this distinction as well. Intermingling business and personal accounts will only lead to confusion about profits, losses, expenses, taxes, and more. You want to make sure your practice is (at the very least) sustainable, so knowing the numbers behind those supplies, rent, shipping, and other expenses is important. And as your practice grows, you'll be confronted with tax documents that inform the government exactly how much you earned. Knowing the exact numbers will help prevent you from overpaying, underpaying, and enduring any audits.

1. OBTAIN A BUSINESS LICENSE

Start by obtaining a business license from your state's Secretary of State office. Once complete, apply for an employer identification number (EIN) through the IRS's website.

2. OPEN A SEPARATE BUSINESS CHECKING ACCOUNT

Find a well-established bank that has partnerships with third-party applications and other financial businesses. Most major banks can connect to different payment and accounting apps. To open an account, you'll need an identification document, such as a driver's license, your Social Security Number or EIN (also known as a tax ID number), and a business license or business name filing document, such as a DBA (Doing Business As) form.

3. CREDIT/DEBIT CARD

After opening your business-only bank account, get a debit card or credit card for the account. ONLY use this card for art-related purposes. It will electronically record all transactions, such as buying supplies, shipping expenses, and travel. Only spend as much as you can afford and quickly pay the balance.

4. ONLINE ACCOUNTING SOFTWARE

Connect your bank account with an online or computer-based accounting software package; these are usually easy for new subscribers to set up and begin using. Many of them can connect to your bank account, making it very simple to track spending, and create reports, filings, and other documents. One of the most well-known online accounting software packages – and one that I use religiously – is QuickBooks.

YOUR GOOGLES

- Starting a business in + (your location)
- Business license + (your location)
- Apply for an EIN + IRS

- Top accounting software for artists
- PayPal app for small businesses
- Square app for small businesses

PRO TIP – GETTING PAID

While the challenge of creating art is constant, it has never been easier for an artist to accept payment for the works. There are many payment solutions that are perfect for artists who are just starting out, even if there aren't many transactions happening yet. Square and PayPal are easy-to-use and reliable payment alternatives that give individuals the ability to accept credit card payments. Each company provides a way for you to easily keep track of funds you receive from clients. PayPal can even send you a debit card for purchases, and can provide you with access to a line of credit. Both solutions are great when getting your practice off the ground. I would advise you to explore and research new alternatives that frequently pop up.

"A common fallacy is that when you donate a work of art to a nonprofit you, as the maker of it, can deduct the total 'value.' This isn't true. You can only deduct the costs of the materials. It's always a good idea to contact an art-specialist tax preparer.

"Also, check into the IRS 'Hobby/Loss Rule,' which is ever-changing. You must show a profit one out of five years as an artist. Otherwise, (you/your business) is considered a hobbyist."

Charles (Chuck) Parson, artist and professor

TAXES FOR ARTISTS

I know it hurts to hear this, but you need to know as much as possible about your business's tax situation. A great rule of thumb is to set aside approximately 30% of your income for taxes. Many artists, including myself, have gotten into trouble and have been penalized for paying late, or for not paying taxes at all. Ignorance of the tax law is no excuse. I'll start by saying that you need to consult a tax attorney, or an accountant, to confirm that you are taking the right action in the eyes of the law.

Taxes can be tricky, but once you get the hang of the system and deadlines, it becomes much easier to address and manage. For example, paying taxes quarterly will help avoid getting hit with a large number at the end of the year.

SALES TAX

When art is your business, you have to be comfortable dealing with sales tax for any works you sell. Typically, sales taxes are collected by the state and the city where you operate your business. You will need to do your homework and contact your state and local governments about getting a license to collect sales tax and to get a clear understanding of how to go about making quarterly or annual payments. When selling work through a third party, such as a café, fair, or gallery, you'll need to learn how to manage sales taxes for any sales that occur.

SELF-EMPLOYMENT TAX

Self-employment tax is a tax consisting of social security and Medicare taxes, paid by individuals who work for themselves. The self-employment tax is similar to the social security and Medicare taxes withheld from the pay of most wage earners, and that are partially paid by employers. When you are self-employed, you must pay all of this yourself.

TARIFFS AND DUTIES

When shipping artwork to another country, you will encounter the dreaded tariff, or duty question. Tariffs are basically indirect taxes imposed by the government of the destination country on goods imported during international trade. These vary depending on the country, the type of item imported, the purpose of the item, and the value of the item.

YOUR GOOGLES

- IRS.gov self-employment tax
- (Your current state) + sales tax
- (Your current city) + sales tax
- Tariff code for artwork + (destination)
- (Your location) + tax and licensing division

HOMEWORK

What are the sales taxes for your city and state?

What tariffs and duties should you be aware of?

Find several local tax attorneys in your area.

Call and schedule an appointment with the local tax and licensing division, and ask them any questions you have about the licenses needed and taxes involved in selling art in the area. You don't want to be blindsided with an unexpected tax bill, so gather as much information as you can.

> "Don't avoid; don't wait. Bad news doesn't get better with time and your tax bill, penalties, and interest only get worse if you don't address the situation head-on. Most artists hope to grow and sustain a living through their artistry. Use financial best practices early on (claiming all earned income, maintaining accurate records of expenses, and filing taxes on time) as you prepare for the large sponsors and commissions."
>
> **Esohe Galbreath**, accountant and curator

DIVERSIFY YOUR INCOME

I'm all about artists making art a business because, in many respects, a sustainable practice *is* a business. I damn near made it my entire livelihood. I took the leap and now I rely strictly on the art opportunities that I find and that find me. It's okay if you don't make your practice your livelihood, but for those who do, diversifying your income is extremely important. For one, your art should be made through the lens of experimenting, exploring, and taking risks, and not strictly in pursuit of dollar signs, because that's how "bad art" creeps in. And you don't want that. Multiple income streams free your practice from some of the worst financial stressors.

Diversifying doesn't mean totally diverging from your creative roots or temporarily abandoning your practice. It's more than having to drive Uber, or wait tables to fill in the income gaps. Because of new avenues available in today's art world, your extra income can come from many different sources related to your creative goals. My practice relies on sponsorships, royalties, speaking engagements, grants, proposal fees, licensing, and consulting work. These all link to the creative world, but none depend on me picking up a paintbrush. All these activities not only provide income, but also help improve my practice. And that's the most important part.

Artist Josiah Alan Brooks, also known as Jazza, has amassed 4 million followers for his YouTube channel, which generates millions of views on each video he posts. Over and above his work as an amazing and imaginative illustrator, his YouTube channel, "Draw with Jazza," certainly provides him with an extra income stream. Creatives are taking advantage of sites such as Patreon, which allows your followers to pay a subscription fee to access content on your profile. That content can range from how-to videos, music, art files, behind-the-scenes videos, video hangouts, articles, and more. Imagine a hundred followers paying $20 a month – that's rent!

You don't have to be great on camera. If you're a strong writer, grants can be an option. Some artists have supported themselves just on grant money. There's no excuse not to chase these extra revenue streams, even if they don't come together overnight. They take a lot of effort and time to put together and organize, but if you want to diversify your income with creative activities, it's entirely possible.

YOUR GOOGLES

- Patreon
- YouTube Creator Studio
- Gumroad
- Tipeee
- Flattr
- Kickstarter

POSSIBLE INCOME STREAMS

Grants	Licensing	Merchandise
Corporate sponsorships	Studio assistant	Product line
Corporate partnerships	Fabricator	Art administration
Speaking engagements	Art installer	Art handling
Teaching	YouTube	Freelance design
Mentoring	Patreon	Consulting
Royalties	Fellowships	Conducting workshops

NOTES 'N' DOODLE

IF YOU CAN'T BEAT THE INTERNET... JOIN IT!

"EVERY TIME THERE'S A NEW TOOL, WHETHER IT'S INTERNET OR CELL PHONES OR ANYTHING ELSE, ALL THESE THINGS CAN BE USED FOR GOOD OR EVIL. TECHNOLOGY IS NEUTRAL; IT DEPENDS ON HOW IT'S USED."

RICK SMOLAN

THE INTERNET

The Internet. Whether it's social media, Google images, comment sections, or forums, the truth is that you'll be forced to learn to conform to it, and not it to you. The Internet has brought artists a wealth of opportunities to reach farther, climb higher, and explore more than ever before. It's easy to get lost online in endless cat videos, but if you're focused on using the Internet as a tool for success, it can help you succeed. Whenever I go online, I remember five actions to guide me: research, organize, promote, explore, and connect (ROPEC).

RESEARCH

Using the Internet to research any topic, material, style, history, biography, and more is easier than ever. As an artist who has learned most of his skills from online resources and online courses, I've found the Internet to be a powerful tool for expanding my practice. Libraries and federal institutions are all connected online and provide access to valuable material.

ORGANIZE

Organizing your practice to be as efficient as possible is absolutely achievable with cloud services, calendars, apps, messaging services, and more. Part of your daily online time should be spent organizing your schedule, meetings, inventory, research materials, processes, proposals, and documents.

PROMOTE

It's essential to promote yourself to collectors, galleries, museums, curators, fans, and new markets daily. This doesn't mean simply posting your latest painting on Facebook – it also means showing an active presence, such as responding to emails in a timely manner to promote your professionalism, or updating your website information to reflect current news.

EXPLORE

Sometimes, you have to be Alice and fall down the rabbit hole of the Internet. With the vast number of new cultures that can now grace your laptop and mobile screen, you can have instant access to countless new ideas you've never seen before. It's okay to spend some time just exploring new websites and getting lost in the mix for an hour or two.

CONNECT

Connecting is the most important part of your online time in your practice. You can't physically be everywhere to meet everyone, so connecting with others online should be a consistent habit. Joining forums, groups, boards, and social media should be an active strategy you use to pursue opportunities and to build a strong network.

YOUR GOOGLES

ONLINE RESEARCH RESOURCES

- Archives of American Art
- Google Scholar
- Library of Congress
- Mendeley
- National Register of Historic Places
- Project Gutenberg Internet Archive
- Smithsonian online
- US National Archives
- WikiArt
- Yale University Arts Databases

ONLINE ORGANIZING RESOURCES

- Adobe Creative Cloud
- Artworkarchive.com
- Basecamp
- Dropbox
- Evernote
- Google Docs
- Kunstmatrix
- Office Online
- Trello

ONLINE PROMOTION RESOURCES

(In your selected platforms, reply, schedule, update, and post all the content you need.)

- 500px
- Behance
- Blogs
- DeviantArt
- Emails
- Facebook
- Instagram
- Mailchimp
- Pinterest
- Saatchi Art
- Snapchat
- Tumblr
- Twitter
- Vimeo
- YouTube

ONLINE EXPLORING RESOURCES

- American Art Collector
- Art21
- ArtDaily
- ArtParasites
- The Art Story
- Artsy
- BOOOOOOOM
- Bored Panda
- Colossal
- Communication Arts
- Creative Time
- Curiator
- Great Big Story
- My Modern Met
- Pinterest
- Reddit
- TED Talks
- Time Out

ONLINE CONNECTING RESOURCES

- Art Medium + forum
- ConceptArt + forum
- DeviantArt + forum
- Facebook + (your art)
- Meetup.com + (your art medium)
- Quora Art
- Reddit + (art medium)

169

CLOUD SHARING FOR ARTISTS

Whether you want to be a full-time working artist, or just want to take your part-time art career to the next level, being professional is a major part of the game. With cloud sharing, it has become easier for you to work with galleries, curators, directors, foundations, and other artists. I have used cloud sharing to share artist statements, high-resolution images of work with advertising agencies, tax documents with galleries, profile pictures for blogs, and a plethora of other content that others have requested.

As you become more established, moving to an artwork-management system such as Artwork Archive can help significantly – especially for artists who are starting to regularly show in galleries and museums. Whatever cloud sharing service you use, organize your folders and documents to make them easy for others to access and navigate. I've shown my basic template for how I do this below. Add, delete, and move folders as you feel necessary to make your workflow as seamless as possible. We all do different creative activities, so we will all have a different folder tree.

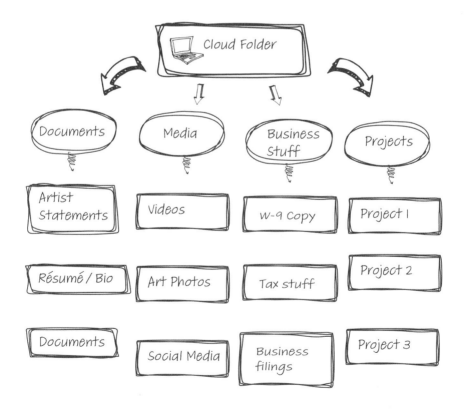

YOUR GOOGLES

• Best cloud sharing services for creatives • Most affordable cloud sharing services

HOMEWORK

Although there are many cloud sharing services, Google Drive is the most widely used across the board. If you don't have a Google email account already, sign up for one and open your Google Drive. Start building your folder map based on the sample.

What folders should you add and which folder(s) could you delete for your practice?

How can you make your cloud sharing map more efficient?

MAKING ART WHERE THE PUBLIC ROAMS

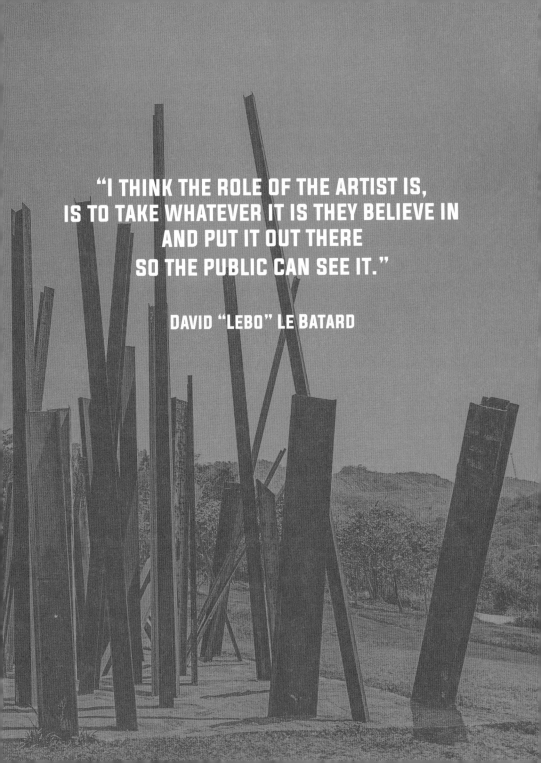

"I THINK THE ROLE OF THE ARTIST IS,
IS TO TAKE WHATEVER IT IS THEY BELIEVE IN
AND PUT IT OUT THERE
SO THE PUBLIC CAN SEE IT."

DAVID "LEBO" LE BATARD

PUBLIC ART

Public art is any art created for the public domain with the intention of public enjoyment. Public art is intimate with its surroundings and it reflects the hopes, dreams, fears, curiosity, history, and current climate in the community. What separates public art from other forms of art is that it is a highly collaborative and communal process, meaning that it involves more than just the creative desires of the artist. Everyone, from artist to elected officials, government employees, community representatives, civil engineers, architects, electricians, landscapers, and donors, will have some degree of involvement in bringing public art to fruition.

OTHER CHARACTERISTICS OF PUBLIC ART

Art can be at a very large scale	General liability insurance requirements
Larger budgets	Longevity and durability of materials
Long project development timeline	Public abuse and vandalism
Multiple approvals and community input	Routine maintenance
Multiple hands involved in fabrication	Starts with request for qualification

SO, WHERE DO I START?

There is a clear Catch-22 in landing a public art project. To get hired to create public art, approval committees want to see a portfolio of previous public works you have done. I'm sure you can understand this requirement, given the large budget and logistics involved. Those involved in the approval process want to be sure the artist can deliver on their proposal.

So, you ask, where do I start? The answer is to start with small projects and grow. School projects, local businesses, self-initiated public art projects are stepping stones and portfolio builders. You'll steadily gain experience working with larger budgets and scheduling, and you will also start to learn how to work with fabricators, electricians, carpenters, installers, aerial lifts, and more. As you start to grow the number and size of your projects, you demonstrate you are capable of the responsibilities required for larger projects.

FINDING OPEN CALLS

Municipalities, universities, and other large establishments frequently have open calls for portfolio submissions for consideration of a specific public art project. Get familiar with some of the popular sites that publish these open calls. I added a number of the most popular websites in the following "Your Googles" section. Visit those sites and research many of the live calls. If you can, apply to some of these open calls and become familiar with the initial process. You want to be as comfortable as possible applying to calls as they pop up.

YOUR GOOGLES

• Public art + (your location)

• Public art workshop + (your location)

• (Your location) + art council + public art

HOMEWORK

Visit some of the following "open call" websites that host databases for public art and more. Search throughout the databases to view some of the open call projects that fit your practice. They all have deadlines, so bookmark them *and* write them down, so you won't forget to apply. Get into the habit of doing this action monthly.

• www.americansforthearts.org

• www.a-n.co.uk

• www.artdeadline.com

• www.artopportunitiesmonthly.com

• www.callforentry.org

• www.competitions.org

• www.publicartist.org

• www.sculpture.org

• www.TheArtGuide.com

• www.theartlist.com

"I think we are seeing programs around the country that are opening themselves up, especially within a certain budget range, to artists that have not completed a public project before. I think that will continue to change. I think program directors and municipalities are understanding that even though they will have some more management duties associated with an artist that hasn't completed a public contract, they are willing to take a little more risk. Their programs are looking to do that to help bring artists into their fold or increase the exposure their program has to a new group of artists."

John Grant, Denver Public Art Services

TIPS WHEN DIVING INTO PUBLIC ART

JUST JUMP IN

The hardest part of getting into public art is getting over the psychological barriers that make you feel out of your league or unprepared. Know that all artists, no matter how successful, had to start from zero. This should give you comfort in taking that initial step to apply.

DON'T PROMISE A DREAM YOU CAN'T DELIVER

Don't include techniques, technology, or materials you haven't used or are not familiar with. You don't want to encounter problems you don't know how to solve. Running into a situation where you're not able to reasonably deliver on promises may even put you in a predicament of having to return deposits.

BUDGET IS KEY

Public art projects take months and years to complete, and are divided into many stages. Payments are usually broken into those stages, so budgeting your cash flow is important. You need to know exactly how much each stage will cost to complete and communicate that before the payment schedule is finalized.

DON'T EXPECT TO GET RICH

Looking at some of the budgets for public art, you'd think that winning a commission would be like hitting the lottery. Artists' fees usually account for 15–20% of the overall budget. The rest of the budget will be swallowed up by fabrication, shipping, and installation costs.

THINK ABOUT THE LONG-TERM

Your public art needs to last for the foreseeable future. During your ideation phase, think about durability and maintenance requirements for your public work. If you're using technology, will the technology become outdated, or malfunction? If so, what then?

INFLUENTIAL PUBLIC ARTISTS

- Lawrence Argent + I see what you mean
- Arturo Di Modica + Raging Bull
- Sir Anish Kapoor + Cloud Gate
- Claes Oldenburg + Spoonbridge and Cherry

FABRICATION

- (Your location) + fabrication studios
- (Your location) + metal working
- (Your location) + art installers

INSURANCE

- General liability insurance

"What I encourage people to do is choose a morning. Maybe it's Thursday, maybe it's Tuesday. You get up half an hour earlier. You get online and you go to the three or four sites that aggregate these opportunities. You look to see that week if there are any opportunities that call your name out, or seem like your work might be appropriate for, or, you're just applying for everything, which is what I encourage people to do. It doesn't take anything. It's free to apply. Put yourself on the pile because you never know where you're going to get picked up. But choose that day once a week. You look at the opportunities. And if there're two, that's two you apply for. But you're consistent and constantly putting yourself out there, your images out there, and your name out there."

John Grant, Denver Public Art Services

STREET ART

Today, street art has hit the mainstream. City governments and neighborhood boards are now more aware of how street art can set the pulse of their community. Like public art commissioned by an organization, street art is displayed in a public location for the public to view and enjoy. However, street art is typically not communal in nature. It's rooted in self-expression. When it comes to street art, there are no limits. Tools, materials, subjects, and size are all up to your interpretation.

THE ESSENCE OF PUBLIC ART

The essence of street art is the need to fit artistic expression into the surrounding environment, reflecting the community. One of your goals should be to push the envelope. Experiment with tools you'll use and surfaces for installation. Street artist Vhils has set himself apart by using a jackhammer to create his murals. Vhils literally subtracts from the wall's surface, while simultaneously adding artistic value. There are many artists who push the envelope. Art collective Ladies Fancywork Society and artist Artur Bordalo are just two, to name a few. Be bold and be daring. If the goal of your work is to be pretty, you've already lost the point. One of the quickest ways to get familiar with all the nuances of street art is to volunteer your time and labor to experienced street artists.

FINDING SPACES

With street art, walls, streets, sidewalks, windows, trees, fences, power boxes, bus stops, and more are all possible canvases. Finding spaces is the easy part, while finding out who owns or controls the space is a lot more difficult. Potential spaces can be privately owned, or government owned. A privately owned space may have local owners, or it could be an investment group that is located in another city, state, or country. You have to do the digging to find out who you'll need to get permission from. In the US, your county's tax assessor's office has information on all property within its boundaries. From there, use an online real estate tool such as Loopnet, Zillow, and Google to search for a property's owner. Sometimes, finding out who owns a property is as easy as just walking into the establishment and asking.

PROPOSAL

Get familiar with writing proposals! Proposals are commonly used to create buy-in from potential business owners, developers, art consulting firms, and funders. A proposal communicates your vision for a space where you're requesting to install art. Proposals should include mock-ups, a timeline, budgets, CV, portfolio, and logistical needs. An important note is that businesses and developers are always concerned about expenses. Finding outside funding sources, or communicating how the art will add value, will increase your chances of getting approval. The goal of a proposal is to have the reader feel as if they can walk into your vision, so if you feel there's more that you can do to deliver that vision, do it.

YOUR GOOGLES

• (Your local county) + tax assessor's office
• AgentPro247

• Loopnet

NOTES 'N' DOODLE

"Murals and street art are easy. It's a wall out on the street. Find a street, find a wall, and ask to see if you can do it. I think the biggest part of street art is asking. A lot of people are afraid to hear 'no.' They fear rejection. All you have to do is ask. And honestly, I wish I would have started earlier if I knew how easy it is to create murals. The liquor store, your own room, you can start anywhere."

Juan "Joon" Alvarado, artist and illustrator

MATERIALS

The types of materials you use are important. There are many things to take into account for the various conditions you may encounter on-site – everything from the time of day and the texture of the wall, to the average humidity and availability of paint in that location. There's nothing more devastating than bringing the wrong materials when tackling a gig. Below are some of the conditions you should account for when deciding on materials and tools.

SOURCING

Regardless of where your project is located, you'll have to plan on sourcing the materials you'll need. Ensure that you can first obtain those materials in that local area and replenish those materials when they run low. This is much more important when traveling to smaller cities or different countries to create street art. If your preferred materials aren't available, you will need to make adjustments or arrangements – preferably before it becomes a problem.

CLIMATE

Local climate can drastically affect the drying time of your chosen material. I love painting, but waiting for latex paint to dry in humid Miami is not the way I want to spend my time. So guess where I avoid using latex paint? Miami. Ask yourself, how cold or hot does it get in this area? How much sun will beat down on my work in this location? Answering these types of questions helps you choose the best materials to use and that will also protect your work.

LOCATION AND SURFACE

The best materials also depend on the location of the work. Is it on a textured brick wall or smooth concrete? Will you have to clean and prime the wall first or is it okay to paint directly on top? What's the best paint for sidewalks and how do you seal it? The location can not only determine the best material to use, but also the best approach or technique to use.

INTERIOR VS. EXTERIOR

There are some materials that are best utilized outside, and some that are best utilized inside. For example, using toxic substances such as aerosol spray in close quarters is a pretty bad idea, so you may be forced to find an alternative material or work after hours when the space is devoid of people. Different materials often have different formulas for interior and exterior uses. Always take this into account because it is important that the materials can be applied and withstand environmental pressures.

Don't be afraid to ask other artists questions about their process and experience with particular materials. I learned by asking, watching, and experimenting. It's not like there's school on this subject, so other artists are usually helpful when it comes to sharing this knowledge.

YOUR GOOGLES

ARTISTS FAMOUS FOR UNIQUE TECHNIQUES

- Artur Bordalo Art
- Banksy
- Birdcap
- FAILE and BÄST
- Gamma Gallery
- Kelly Goeller
- Konstantin Dimopoulos

- Ladies Fancywork Society
- Diogo Machado – Add Fuel
- Patrick Kane McGregor
- Retna Art
- Swoon
- Vhils
- Sean Yoro – Hula art

COMMONLY USED MATERIALS AND TOOLS

- 1 Shot Oil Paints
- Chalk
- Handheld paint sprayer
- Krink markers
- Large brushes
- Latex paint

- Montana Gold spray paint
- MTN 94 spray paint
- Painter's tape
- Rollers
- Spray bottles

SCALING-UP WORK

Techniques for translating work from ideation to a large platform vary from artist to artist. Not only is each artist's process different, but the texture and layout of the surface on which you plan to install work will vary, so a mix of tools, techniques, and methods may be used. Google each of these methods to learn more about how best to incorporate them into your practice.

Freehand sketch	Stencil method
Grid system	Wheatpasting
Pouncing method	Vinyl wrap
Projector	

PERMITS AND LOGISTICS

With anything public, you should inquire about logistics and any permits required. Every location is different because every state, city, and neighborhood has different rules. You don't want a city official stopping you in the middle of a public project because you don't have the proper permit. Or even worse, having the city cover up your work right after you've completed it because it wasn't sanctioned. You can always Google local statutes, or call your local municipality for clarity.

PRICING

There's no hard rule for how much to charge for commissions. Some artists charge by the square foot, while others charge a flat fee. To be honest, you can never dial in a perfect formula because all projects will present you with costly challenges. To find a reasonable price range, assess each project by asking yourself the following questions:

How much time will it take to complete the project?	Where is this project located? Is it local, or do I have to travel?
How many supplies are needed for this project?	What agreement is there about the maintenance for the project post-completion?
Are any permits required?	
What do the permits cost?	Will I be working in harsh weather or extreme temperatures? How much is my comfort worth?
What equipment do I need? Scaffolding, ladder, scissor lift, boom lift, nothing?	

YOUR GOOGLES

- Wheatpasting 101
- Best projectors for artists
- Chalk line for grids
- Pouncing art tools
- Best latex paint for outdoors

- Anti-graffiti coating
- Aerial equipment rental
- Scaffolding rental
- Outdoor mural permit
- Public art permits

NOTES 'N' DOODLE

"The mural price usually depends on difficulty, travel, and square footage. I try to be consistent with my pricing and give the client a clear breakdown on why I'm charging what I'm charging."

Luis Valle, artist and muralist

THE VISUAL ARTISTS RIGHTS ACT

Before December 1, 1990, artists had little to no right to protect their work from mutilation, misattribution, or destruction. Today, artists enjoy the benefits of the Visual Artists Rights Act (VARA).

These rights are limited to the fine arts, such as paintings, sculptures, drawings, prints, and still photographs that are produced for exhibition. Furthermore, these rights are limited to single copies or limited editions of fewer than 200 copies. In the simplest terms, under certain conditions, artists who create unique works, and are of recognized stature, retain the rights so that the owner of their work cannot alter, distort, misattribute, or mutilate their work. VARA rights last for the life of the artist, or in case of joint work, the last surviving artist.

Today, VARA is widely used by sculptors, muralists, and other public arts artists to protect their work, and the effects are being felt in many places. Graffiti artists in New York sued property owner Jerry Wolkoff for destroying legal graffiti art that had been painted on his building without giving the artists proper notice so they could document their work. Wolkoff's property, nicknamed "5Pointz," was a mecca for artists to legally paint on. After decades of owning the building, Wolkoff wanted to knock it down and develop condos. Following pushback from the street arts community, Wolkoff destroyed all the art that was painted on his building. Using VARA, the artists sued for reparations and were eventually awarded $6.7 million in damages.

Los Angeles–based artist Kent Twitchell had a 70-foot mural of fellow artist Ed Ruscha whitewashed without the 90 days' prior notice that VARA requires. Twitchell sued the Department of Labor for $5.5 million and was awarded a $1.1 million settlement. This was a far cry from what happened to *Tilted Arc*, a controversial public sculpture by artist Richard Serra, that was installed before the VARA was enacted. *Tilted Arc* was a 120-foot long, 12-foot high, solid, unfinished plate of rust-covered steel that was installed in Foley Federal Plaza in Manhattan, New York. The community considered the sculpture ugly and argued for its removal. After a jury of five voted 4–1 to remove the sculpture, it was moved to storage, never to be seen again.

Become familiar with the basic VARA protections, because knowing that your work has rights can make all the difference in how your work is preserved.

YOUR GOOGLES

- 5Points Graffiti case
- *Tilted Arc* by Richard Serra
- Kent Twitchell mural
- Jerry Wolkoff
- Visual Artists Rights Act (VARA)

VISUAL ARTISTS RIGHTS ACT

Per 17 US Code § 106A, VARA grants the right:

- to claim authorship of that work, and
- to prevent the use of his or her name as the author of any work of visual art which he or she did not create;
- to prevent the use of his or her name as the author of the work of visual art in the event of a distortion, mutilation, or other modification of the work which would be prejudicial to his or her honor or reputation; and
- to prevent any intentional distortion, mutilation, or other modification of that work which would be prejudicial to his or her honor or reputation, and any intentional distortion, mutilation, or modification of that work is a violation of that right; and
- to prevent any destruction of a work of recognized stature, and any intentional or grossly negligent destruction of that work is a violation of that right.

PROTECT YOURSELF AND YOUR WORK

"IF YOU MAKE GOOD ART,
PEOPLE WILL COME
AND TRY TO TAKE IT."

THOMAS "DETOUR" EVANS

COPYRIGHT

As an artist, you'll need to know about copyrights. Especially in this age of social media, your work is proliferating around the Internet at light speed for anyone to see and possibly use. Copyright basically allows you to take control of your creative capital. It gives the person who holds, or owns, the copyright the right to copy the work – hence, "copy" and "right."

According to the US government's copyright website, www.copyright.gov, a copyright is a form of protection provided by US laws, and it covers "original works of authorship," including literary, dramatic, musical, architectural, cartographic, choreographic, pantomimic, pictorial, graphic, sculptural, and audiovisual creations. While "copyright" in its most pure sense means the right to copy, it has come to cover the entire body of exclusive rights, granted by law, to copyright owners for protection of their work.

YOU ARE GRANTED THE RIGHT TO...

Reproduce the copyrighted work in copies, or phonorecords (physical or digital format);

Prepare derivative works based upon the copyrighted work;

Distribute copies, or phonorecords, of the copyrighted work to the public by sale or other transfer of ownership, or by rental, lease, or lending;

In the case of literary, musical, dramatic, and choreographic works, pantomimes, and motion pictures and other audiovisual works, to perform the copyrighted work publicly;

In the case of literary, musical, dramatic, and choreographic works, pantomimes, and pictorial, graphic, or sculptural works, including the individual images of a motion picture or other audiovisual work, to display the copyrighted work publicly;

In the case of sound recordings, to perform the copyrighted work publicly by means of a digital audio transmission.

Copyright protection does not extend to any idea, procedure, process, system, title, principle, or discovery. Similarly, names, titles, short phrases, slogans, familiar symbols, mere variations of typographic ornamentation, lettering, coloring, and listings of contents or ingredients are not subject to copyright.

Source: https://www.copyright.gov/

1. For art created after January 1, 1978, a general rule is that copyright protection lasts the life of the author, plus an additional 70 years.

2. When you create original work, from ideation to execution, you own the copyright.

3. When you sell original work, you still retain the copyright.

4. You can gain better protections for you work by registering your copyright with copyright.gov, and this will help you prove ownership.

5. You can sell the right to copy your work in whole or partially to anyone you want.

6. You can take legal action if someone infringes on your copyrights. This is usually in the form of a copyright infringement notification. An example is YouTube's infamous copyright infringement notification, which pops up after uploading a video that uses a soundtrack that is protected by copyright.

COLLABORATIONS, PARTNERSHIPS, AND OTHER GROUPS

When working with others, it's essential to know exactly who owns copyrights to the original works that are being created. You'll regularly fall into these situations. You're working on a screenplay, or music with a friend, and later, the work has become popular and commercially valuable. This scenario plays out many times in the creative world. The best thing to do is to make sure there is clear, documented communication about how ownership of the copyrights are distributed. This communication can be in a formal contract, or even in a chain of email correspondence.

FREELANCE / CONTRACTING

When being hired by established brands, such as Coca-Cola or Apple, there is usually a formal contract that spells out the ownership of the original works being created. In many of these cases, it will say that you are contracted to create the work but you do not own the copyrights. Essentially, it is work made for hire. In cases of many of the brands I've worked with, I signed contracts that explicitly said the brand owns the copyrights to works created for that project, which is very common – but don't get bullied. You can always negotiate the copyrights, or just walk away if you don't feel comfortable.

LEARN ABOUT COPYRIGHTS

As you grow your professional career, you will need to study different situations that your specific practice may encounter. There are way too many to address in this section. The best way to study this sometimes ambiguous topic is by reading real-life case studies where artists and copyrights are in the forefront. Think Shepard Fairey and the famous Obama "Hope" poster, or AholSniffsGlue vs. American Eagle. The more you know about how copyrights are being used in the real world, the better equipped you will be.

REMEMBER, ALWAYS BE WILLING TO WALK AWAY WHEN YOU DON'T FEEL COMFORTABLE.

YOUR GOOGLES

- H&M vs. graffiti artist Revok
- Register copyrights
- Richard Prince Instagram Show lawsuit
- Shepard Fairey vs. The Associated Press
- Damien Hirst copyright lawsuit
- AholSniffsGlue vs. American Eagle
- Lawyers for artists

"To be honest with you, when it comes to copyright, I'm way too busy and [I] hate legalities. At the same time, I take pride in being original, so my work is important to me and I would not appreciate my copyright being infringed upon. I guess I weigh things out. I've had situations where my work was used without permission but sometimes to my benefit. I've worked too hard to get my work out there and I'm flattered whenever anyone feels the need to use it. My issue is when someone tries to make a dollar off something I did with my blood, sweat, and tears, and didn't get paid for. This is a fine-line situation, where it really depends on the case."

Luis Valle, artist and muralist

CREATIVE COMMONS

In the digital age, it is much easier to share your work, which also means it is much easier for people to take and reuse your work. So, how do you share and market your work without the fear of having it taken? Creative Commons (www.creativecommons.org) is an organization working to create a standard system to help artists legally share their creative works under conditions of their choice. Creative Commons provides free and easy-to-use copyright licenses that can fit specific conditions in which you would like to share your work. This is extremely important for many artists who create music, websites, graphic design, photography, video graphics, and other works that can be easily duplicated and remixed.

On the Creative Commons website, you can customize and download your license with a few clicks of a button, and create instant conditions for others to follow when using your work. I recommend that artists working in the digital space become familiar with various conditions they can set for others to access and use their work.

COMMON LICENSE CONDITIONS

ATTRIBUTION (BY)

CC licenses require that others who use your work in any way must give you credit the way you request, but not in a way that suggests you endorse them/their use. If they want to use your work without giving you credit or for endorsement purposes, they must get your permission first.

SHAREALIKE (SA)

You let others copy, distribute, display, perform, and modify your work, as long as they distribute any modified work on the same terms. If they want to distribute modified works under other terms, they must get your permission first.

NONCOMMERCIAL (NC)

You let others copy, distribute, display, perform, and (unless you have chosen "No Derivatives") modify, and use your work for any purpose other than commercially, unless they get your permission first.

NO DERIVATIVES (ND)

You let others copy, distribute, display, and perform only original copies of your work. If others want to modify your work, they must get your permission first.

Source: www.creativecommons.org

NOTES 'N' DOODLE

TRADEMARKS

TRADEMARK

According to the US Patent and Trademark Office, "A trademark is a word, phrase, symbol, and/or design that identifies and distinguishes the source of the goods of one party from those of others." Think about the phrases, symbols, and logos associated with the brand name Nike. From hearing the phrase, "Just Do It," to seeing the Jumpman logo on a pair of Air Jordans, people automatically think "Nike."

For creatives, think about the artist name, or the collective name you use to conduct business. The signature you use to sign your work can be considered a unique mark and helps others easily identify your work. The Walt Disney Company, home of all my childhood imaginations, is actually the name of the founder. Its logo is also an adaptation of his signature. For the vast majority of artists, trademarks are something that probably won't be necessary to protect their practice; however, it is something to think about, as your work may become more commercially viable and need protection. Visit the website www.uspto. gov, or your local country's trademark website, to get more information on how to register a trade name. Even though there is usually a fee to register your trademark or trade name, it just may be worth it in the long run.

AVOIDING INFRINGEMENT

Many artists will appropriate pop culture to create new works, and if they do so using specific brands, this can become tricky. Sometimes, you just don't know how much is too much. Andy Warhol's work was all about appropriating and remixing pop culture. Warhol famously used the Campbell's Soup can in his print work, and he became a household name. It could be confusing as to whether or not Campbell's Soup authorized Andy Warhol to use their trademarked name/image. The confusion that arises from these situations is what artists need to think about. "Is it possible for someone to confuse my appropriation as authorization?" To proactively avoid any infringement problems, some artists add a disclaimer to their website description, or a caption of a particular work using trademarks, explaining that the trademark's use is not authorized by the trademark's owner. While a disclaimer can help address possible confusion, it does not guarantee freedom from liability.

YOUR GOOGLES

- Andy Warhol Campbell's Soup Company trademark
- Jeff Koons trademark
- Nestle vs. Anthony Antonellis
- History of Jumpman logo

HOMEWORK

Visit the Trademark Electronic Search System on the United States Trademark and Patent Office website (uspto.gov) and search some of the following names and items. This will help you get familiar with the Trademark Electronic Search System so you can find what is and is not trademarked.

- Art Basel
- Banksy
- Walt Disney
- Frida Kahlo
- Kendrick Lamar
- Stan Lee
- Spider Man
- Mickey Mouse
- Andy Warhol

DOCUMENTING

Documentation should always be a part of your process. In fact, the more documentation, the better. Your documentation serves as a record of your accomplishments during a specific period of time. This allows others to see not only that specific time period of your career, but when reviewing documentation over a period of time, it tells a story about your journey. You'll need great documentation for:

Gallery submissions	Portfolio	Social media
Look books	Presentations	Websites
Marketing assets	Reproductions	
Open calls submissions	Residency applications	

THE RESOURCES

We don't all have the perfect equipment on hand to document our work. This is 90% of the battle for artists who need to document their work. However, unless you're looking to reproduce picture-perfect prints or gallery-quality photos, many of our smart phones are powerful enough to capture what we need. A couple of phones set on tripods can easily capture what you need to document an experimental dance performance, or spoken word. Netflix used video footage I shot on my iPhone 6 in a video campaign to promote its *David Letterman Show*. Don't let the feeling of not having the best equipment hold you back. One of the greatest tips I ever received was that lighting and angles are everything… AND THIS IS TRUE!

GREAT LIGHTING FROM THE RIGHT ANGLE CAN MAKE DOCUMENTATION BY STANDARD EQUIPMENT LOOK AMAZING!

OUTSOURCING

When the best of the best is needed, outsourcing in an option. Hiring a photographer who specializes in art documentation, or a videographer who has all the equipment you need, is a great option for getting professional results. Many printing companies have scanners that will scan your work, whether it's a small doodle or large painting. Three-dimensional (3-D) modeling companies can three-dimensionally scan a sculpture you created, or an entire room with your installation work. There is no shortage of options, and with the right research, you'll be able to find the resource to help you document anything.

YOUR GOOGLES

- (Your location) + printshop
- (Your location) + art scanning
- (Your location) + 3-D scanning

- Best cameras for artists
- Best camera lens for artists

TOOLS FOR DIY DOCUMENTATION

- Color calibration software
- DSLR cameras
- LED photography lights

- Pancake lens
- Photoshop/Lightroom
- Tripod

NOTES 'N' DOODLE

REPRODUCTIONS AND LICENSING

Reproducing your work is something you may want to explore, because this gives you the option to sell a particular piece of your work without having to sell the original. You can create open editions (unlimited), or a limited number edition of works. You may only want to reproduce certain types of work in your practice and keep others strictly as one-of-a-kind originals. It's all up to your discretion. Depending on your art form, it may be slightly harder to figure out ways of reproducing your work. Prints of a painting and a collection of poetry are dynamically different. Researching how other artists with similar art forms reproduce their work will help spark ideas of how you can reproduce your works.

LICENSING

Sometimes, you'll be approached by people or businesses interested in reproducing your work. Artist KAWS's distinctive work has been reproduced on many commercial items through licensing by big brands. The licensing agreements come in all shapes and sizes, ranging from large brands that want to use your work in commercials, to medium-sized companies that want to use your work for a website, to small grassroots companies that may want to print your work on clothing. Each agreement is different and requires a clear understanding of how your work will be used and how royalties will be distributed.

WHY WOULD YOU WANT TO REPRODUCE YOUR WORK?

Build demand for the original.

Create an affordable price point for your market.

Earn passive income through royalties or licensing fees.

Expand your reach in different markets with larger, more diverse inventory.

QUALITY IS KING

Remember that quality should be your first priority. Reproductions need to represent the quality of your work just as much as the original. Whether it's you reproducing your work, or it's being licensed out, you want your work to communicate the same message; therefore, quality control is necessary. If you decide to use a print-on-demand service online, ensure that you sample the results first. Order your own uploaded artwork from the company, so that you can understand the experience that your customers will go through and so you will know the quality of printing the company performs.

YOUR GOOGLES

- Print shop in + (your location)
- 3-D print shop in + (your location)
- Artist collaboration with + (brand name)
- Sample copyright license agreement
- Artwork licensing agreement
- Exclusive vs. non-exclusive artwork license

PRINT AND FULFILLMENT ON-DEMAND SITES

- DeviantArt
- Fine Art America
- Printful
- Printify
- Redbubble
- Society6
- Zazzle

TAKE TIME TO SHARPEN YOUR AX

"ALWAYS A STUDENT AND NEVER A MASTER.
YOU HAVE TO KEEP MOVING FORWARD."

CONRAD HALL

REFINING YOUR PRACTICE

INSOURCING VS. OUTSOURCING

You will constantly be confronted with the dilemma of whether you should do a task yourself or have someone else do the work for you. Like me, many artists love to stay hands-on in every stage of the process, even though there are many tasks that are too time-consuming or don't require the hands of the artist to be completed. You have to ask yourself, is it the best use of your time and do you have the expertise? If not, consider outsourcing.

I build and paint all my own canvases, but I rely on professional shippers to package and ship my work. Packaging is not my expertise so I turned to outsourcing. Artist Ai Weiwei enlisted more than 1,600 workers over a span of two and a half years to paint 100 million porcelain sunflower seeds for his installation, *Sunflower Seed*, at the Tate Modern museum in London, England. This is extreme, but it hits home the point that outsourcing should be an option when expertise and time are factors.

ELIMINATE SELF-SABOTAGE

Self-sabotage is any behavior, thought, or action that promotes the arrested development of your practice. Case in point, neglecting to spell-check your CV before submitting an application. Another would be – and this is one that I do often – saying yes to projects that have no business in my studio. We all deal with these actions even when we know they hold us back, but we continue to do them anyway. These behaviors, decisions, and thoughts ultimately prevent us from reaching our goals. Procrastinating on projects does nothing other than make you miss deadlines and screw up your schedules. Not applying for a group show because you thought the gallery was too high-end eliminated you from being in the running altogether.

We self-sabotage because subconsciously we either want to protect ourselves from disappointment, or we are afraid of the expectations and responsibility that are required on a bigger stage. I want you to know that this is something that everyone deals with. We all have different ways of self-sabotaging our own careers to different degrees. Understanding that we have to identify these behaviors, thoughts, and actions is the first step. Taking action to eliminate them is the second step. Regardless of how much you grow and evolve, self-sabotage will always be a theme that pops up, so it will be your job to knock it back down when you spot it.

• Ai Weiwei + sunflower seeds

SHOULD I INSOURCE OR OUTSOURCE?

Would my time be better spent outsourcing and focusing my efforts on a more important task?

Do I have the equipment and the knowledge to complete the task?

Is it important to the work's message that the task be done by the artist?

Do I have the materials to complete the task?

What are the costs involved with outsourcing vs. completing the task in-house?

REFINING YOUR PRACTICE
A TIMELINE

TEACH OTHERS HOW TO RESPECT YOUR PRACTICE

I am always upset when I hear artists getting taken advantage of. *"Our company can't pay you for your time but we can give you some exposure."* Are you serious? *"Can you donate an original piece of art by tomorrow?"* Wait, what? Really? As an artist looking to turn your practice into a livelihood, it is essential that others respect you and your practice just as much as they would any other museum, gallery, business, nonprofit, or other organization. Like other entities, you should set boundaries.

Just by giving a clear no, you let others know what you are willing and not willing to tolerate. *"Can you do some work for a gift card?"* Response: "Unfortunately, I'm not able to accept that offer because I have cash expenses associated with creating my work." Others will quickly realize that you have a boundary that can't be crossed. They'll know not to approach you looking for free work, or free labor, or even approach you with the dreaded unannounced visits.

DON'T FALL FOR THE EXPOSURE PITCH

The exposure pitch is any time an entity, regardless of size, requests any type of creative labor or work in exchange for you getting to be in their presence... in other words, *exposure*. My friend Jon Lamb always responds to companies using the exposure pitch by saying, "I can die from exposure... sun... snow... and companies not paying me."

Companies that use this tactic to reduce expenses have most likely allocated the majority of their budget to services such as catering, event productions, facilities, staff, talent, and more. These expenses can really balloon. The problem is that many companies don't view creatives as people who need to be compensated, the same way a caterer or staff does. This is because many artists have taken opportunities from companies just for the exposure, and now the idea that artists can be bought for "exposure" is ingrained into the company's very belief system. *"Well, we can't pay but there's going to be 1,000 people coming to the event. It's great exposure."*

Strive to avoid viewing exposure as a form of currency! There are exceptions, but in most situations, you will want to make sure that your time, work, and energy are valued and respected. Not only that, you need to set the standard for how companies will treat the next artist after you. Sometimes, all it takes is a little pushback and you'll start to notice how companies stop using exposure in their pitch.

PRESENTATION

Making work is easy. Figuring out how to display your work can be difficult. How do you display your work so that its context is that much more potent? What can you include in the space that will allow the work to stand out or emphasize particular features? The white walls and clean floors are not just for hanging and standing anymore – they can be an extension of the work. Focus on experimenting not only with your work but with how your work is displayed. Work on finding that visual language that you can apply to displaying your work, because your work can take another level of meaning when you craft new ways of displaying it.

GREAT THINGS ARE NOT DONE BY IMPULSE, BUT BY A SERIES OF SMALL THINGS BROUGHT TOGETHER. AND GREAT THINGS ARE NOT ACCIDENTAL, BUT MUST CERTAINLY BE WILLED.

Vincent van Gogh

INCREMENTAL GOALS AND IMPROVEMENTS

Focusing on growing and evolving is important to your career. Finding the time, space, and resources to grow can be difficult, however. I have found that engaging in incremental experimentation and finding solutions to challenges in each and every project I take on leads to significant changes over time. It can be as simple as shooting in a different location if you're a photographer or adding a color of fabric you never used before if you're a fashion designer.

LEARN YOUR MATERIAL

Understanding your tools and materials will make your practice flexible. When you learn to bypass the art store and make your canvas, paints, molds, and other items, you'll be able to free yourself from reliance on prepackaged products, and create custom solution to creative problems. There's no section in the local art store to tell you how to create a thousand-pound hand sculpture, carved from thousands of pieces of individual wood, but artist Andrew Tirado knows how. Specifically, he can do this because he understands his materials and tools enough to mold them into whatever he pleases. Know the DNA of your materials and how they interact with surrounding environments.

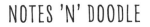

> *"While I have experience working around largely blue chip or widely known artists' work, I have seen trends in how their work is displayed. These can go in directions [such as], are they centered culturally, or is there a common projection of their work into the world? I have also found the best curatorial strategies used when working with an existing museum's space. I have seen contemporary artists disrupt patterns of engagement by curating works that speak to an existing arrangement. For example, Ebony Patterson and Joshua Johnson at the Baltimore Museum of Art. This strategy reinterprets the way knowledge is disrupted."*

Antoine Girard, artist, curator, and Broad Art Museum staff member

> *"I always find it important to set goals with each new body of work. I set a desired 'effect' or level of detail to learn, and then challenge myself to get there. It is a constant chase to better my skill set, one that I don't think I'll ever win, but I believe it is that chase that allows me to up my game incrementally with each new series of paintings. I think it's the continued hunger and excitement to get better at my craft that measures my growth."*

Greg "Craola" Simkins, artist

THE SHIT
THEY
SHOULD
HAVE
TOLD ME

"THERE'S A DIFFERENCE BETWEEN EDUCATION AND CERTIFICATION. CERTIFICATION IS ACHIEVED THROUGH SCHOOL BUT EDUCATION IS SOMETHING YOU ACQUIRE THROUGH KNOWLEDGE AND EXPERIENCE."

CHARLAMAGNE THA GOD

COMMUNICATION IS KEY

Learn to communicate your ideas effectively and efficiently. I can't stress this enough. From talking to potential audiences about why they should attend your next performance or exhibit, to explaining to a client why your approach is the best solution for a project, being able to communicate your ideas, thoughts, and concerns effectively is a must. Businesses are all about telling us why their product is the best brand on the market. You have to do the same. You can have great work and ideas, but if you can't explain them, you will surely encounter hurdles throughout your journey.

WHAT GOOD IS AN IDEA IF YOU DON'T EVEN KNOW HOW TO EXPLAIN IT?

PAINT A VIVID PICTURE

Albert Einstein once said, "If you can't explain it to a six year old, you don't understand it yourself." As creatives, we have abstract ideas that aren't fully fleshed out, and those ideas are, many times, ours alone. And as creatives, it's our job to pull those ideas out of our head in a way that helps others visualize our thoughts. If you can't explain what you want and need, how do you expect others to know what you want and need?

A classic film that transformed animation, *Snow White and the Seven Dwarfs,* started as a performance on a sound stage. Walt Disney actually acted out the entire *Snow White* script, evoking all the emotions and personality of each and every character for his staff, to help them capture the vision he had for the film. Disney painted a vivid picture for his employees; his theatrical performance spoke directly to the creative imagination of those watching. He simply had an idea and knew how to communicate that abstract idea effectively.

WORK ON YOUR PRESENTATION SKILLS

Your presentation skills are more than just verbal communication and hand gestures. They should include knowing what you need to do to help others visualize your thoughts. Learning how to utilize PowerPoint presentations, design sketches, fabric samples, and performance demos should be a big part of honing your presentations skills. Artist and architect Kelton Osborn regularly creates miniature samples of his sculptures when presenting to committees for public art. This tactic helps decision makers visualize Kelton's idea by giving them something tangible that they can hold.

HOMEWORK: QUESTIONS TO ASK YOURSELF

Who is the audience?

Why should people care?

How do they receive information?

What are their needs?

How can I help them visualize my message?

KNOW YOUR AUDIENCE

Communication is a two-way channel. One person sends information and another person receives it. One of your jobs as a creative is to figure out how your audience bests receives information. This will change from person to person and from task to task because everyone has different wants and needs. Communicating with a gallerist about your work will be different than talking to a client about a project budget or discussing your work during an artist talk. These people all have different wants and needs that you should try to address.

Who is the audience?

Why should people care?

How do they receive information?

What are their needs?

How can I help them visualize my message?

TALK ABOUT YOUR IDEAS AND CONCEPTS WITH OTHERS

Consistently discussing your ideas and concepts with others allows you to practice verbal communication. And, YES, you need to practice that. Even the best speakers in the world practice verbally delivering information. As you become comfortable with talking to people about your ideas, you'll gradually start to understand the talking points that best resonate with your audience's wants and needs. You'll become more proficient at reading people and responding to feedback. During my early 20s, I regularly performed stand-up comedy at open mic nights and comedy clubs. This wasn't a passion of mine; I just liked making people laugh and I saw that the more I performed, the more comfortable I was with talking about my thoughts. Look for opportunities that allow you to do the same. Practice, practice, practice.

IMPROVE YOUR WRITING SKILLS BY ACTUALLY WRITING

As a professional artist, you will regularly have to write about your work or about yourself. Keep a notebook and write your ideas as they come to you. Just write, write, write. The act of writing forces you to solidify your thoughts in a more tangible form – this is especially true for creatives, who spend a lot of time in their own heads. As your thoughts come together, you can see them, analyze them, dissect them, scrutinize them, bend them, break them, and reshape them. You'll find that the vocabulary you use to describe your practice will become more clear, and writing about yourself, your work, and your needs will get easier.

HOMEWORK

Write the first 10 words that describes the work you do. Go into detail on each, and describe why it resonates to your practice.

Read an interview of an artist you admire. Then answer the questions as if they were being asked of you.

SOMETIMES IT'S A NUMBERS GAME

To open doors in life, you must first be willing to knock on them. You have to be willing to hear a thousand instances of "no" to get to that one "yes." It's no different in the art world. Knocking on doors, sending emails, writing press release after press release, making phone call after phone call, are all part of the job. You should never get discouraged when hearing phrases such as, "Come back later," "It's not for us," "We're going in a different direction," "We actually found another artist," or just plain "No." These are responses that I commonly receive, more often than "yes."

After I was invited to paint my first mural at a festival, I was hooked on painting walls. However, it was up to me to find walls to paint afterward. This led me to walk from building to building, asking business owners and managers if they would allow me to paint on their walls. Hundreds said no, for one reason or another, but I was only concerned about getting that next "yes." That "yes" became the catalyst for all the murals I've painted since. Not only that, with all the people I had approached, my tolerance for rejection increased and I became knowledgeable about the best ways to approach business owners and managers. Sometimes, you have to verbally walk through a mountain of "nos" to get to the other side.

Lindsey Lamb, of the Denver-based print and design shop Like Minded Productions, says that her business uses a method called "9–3–1" when seeking print, mural, and design opportunities. Lindsey explains that out of every 9 potential clients, 3 will be interested, and 1 will act on her or his interest. With this as a baseline ratio, when they reach out to a number of clients, they know that only a third will seem interested, and then only a third of those who are interested might turn into real opportunities. Regardless of what ratio is used, she said, it ultimately breaks down to how many people you have approached.

In your practice, especially at the beginning of your career, learn to battle through the rejection and understand that, at times, it's a numbers game. Don't just submit to one group show – apply to all the group shows your work suits. Don't just apply for one residency – apply to all the residencies you qualify for. Always think of ways to improve your chances, but understand that you will, very likely, still have to go through a mountain of "nos" to get to the one "yes."

HOMEWORK

Start putting together a list of different tasks that require you to open yourself up to rejection. These tasks can be as simple as approaching galleries about representation, or applying to residencies around the world. Within those tasks, make a list of 20 different entities to approach, and then get to work!

WORK AND INSTALLATION

Gallerists and curators (and even many artists) see space as a blank canvas, and artwork as the paint. As artists drop off work for solo and group shows, the curators and gallerists are hard at work, composing a well balanced show. One of the biggest complaints that I hear from art installers and gallery owners is that artists know how to create the work but damn sure don't know how to display it. This is something that all curators, installers, and gallery and museum staff encounter when working with artists.

DISPLAY SECOND

Every piece that is displayed in an exhibit is unique. As you're creating work, your materials, shape, and form might end up being quite unique, in that they are untraditional. Ensure that you incorporate ideas on how you are going to display your work and how to make it as easy as possible for gallerists, art installers, and curators to handle and install. Is it on a pedestal or is it on a wall? If the work is to be hung on a wall, how? How much weight can this wall handle? Do I need to attach loops if my work needs to be suspended from the ceiling? These are some of the initial questions that you should address to make it simple for others to install your work. Curators, gallerists, and installers didn't make the work, so provide as much information and assistance as you can, along with the necessary tools and materials to display your work the way you envision.

THE PERFECT HEIGHT

Is there a right height to hang work? Well, many traditional works are usually hung so that the centerline of the work is at 57 inches from the floor. This is because 57" is the average sight-line for a human being. Although hanging work at this height will lead to having an appealing display for a majority of the audience, display your work the way you wish it to be seen. It's okay to get unorthodox and a little strange.

LOCATION MATTERS

As you grow as an artist and start to venture outside of your local area to present works, the norms of displaying work in a new location becomes a factor. When I lived in France and Argentina, I often saw work hanging from suspended wires, because the gallery walls were concrete rather than drywall. This had a big effect on how I prepared my work for hanging and display purposes. Always take into account location when sending work outside of your local area, and especially out of country.

216

NOTES 'N' DOODLE

IDENTITY AND POLITICS

Art critic Jerry Saltz said that all art is identity art because somebody made it. It took me a while to really understand that statement, but as I discovered more about the art world, this statement has repeatedly resurfaced. As artists we explore and then express our various identities and the communities that we attach ourselves to. Race, age, gender, nationality, religious affiliation, sexual orientation, geographical roots, and social views can all be a part of that conversation. As much as artists address this conversation, galleries, residencies, collectors, curators, museums, fairs, grants, and fellowships are a part of the conversation as well. Some artists, more than others, may feel the effects of this throughout their career. Whether it's the residency you participate in or the opportunities that you're consistently being approached with, your identity can play a significant role in your career.

I wanted to bring attention to this conversation because the role that identity plays in art today is rarely brought up in the creative community. We notice it, but many times we either avoid or glaze over the discussion of how identity touches every part of the art world. Does an artist being from a particular community feel pressure to make work from and representing that particular community? How does my identity affect my chances of being accepted for this particular opportunity? Does my identity precede my work?

Your race, ethnicity, gender, or sexual orientation may play a significant role in the exhibitions you are invited to participate in, or it can be a factor to some collectors who want to collect art from specific types of artists. I have met many collectors, for example, who only collect art made by women. There are many other collectors who do the same with other communities. Many residencies focus on artists of a particular ethnicity, age, or gender because their larger mission focuses on those specific communities.

Your identity can open doors that may be closed to others. Take advantage of those open doors by walking through them, because those openings are there for a reason. For many years, various communities were excluded from the art conversation. Today, many organizations are trying to level the playing field by awarding communities that were undervalued and neglected by the art world. The La Napoule Art Foundation has an annual art residency that invites artists who work in different creative forms from different parts of the world to live and work in France for a month. Their selection process generates pools of artists who are intentionally different to offer a wide swath of communities the opportunity to participate in the art conversation.

Identity can be tricky because reality is 99% perception. Many times it's someone else's perception that can affect a creative's practice. You may feel pigeonholed, stereotyped, pressured, or expected to produces certain types of work. Many times it's out of our control. People will make judgments without us even knowing. Good or bad, chances are that identity will play a role in your practice – it's important to be aware of this up front.

HOMEWORK

List some of the communities that you identify with, and how those communities navigate the art world.

GOING ABOVE AND BEYOND

To become what you want to be in life, you have to be willing to do things that others aren't willing to do. You have to be willing to go where others won't, to say things that others can't, and to be things others aren't willing to be. As an artist, when it comes to your practice, don't expect to produce amazing work by putting in average effort. If you are truly wanting to create work that impacts people, your efforts have go beyond the norm.

Brooklyn-based artist Tatyana Fazlalizadeh created an entire street art campaign around her work dealing with street harassment toward women. Her posters usually depict a women and some sort of statement. Many similar campaigns, mostly created by large institutions, were digitally based. However, Fazlalizadeh used her illustration skills to go from the studio to the walls, by wheatpasting her art around her Brooklyn neighborhood at night. The effort to use street art as a vehicle to communicate this sort of message wasn't being utilized by other artists. Fazlalizadeh's efforts in that space were new and fresh, and her campaign has now grown to multiple cities and counties.

In 2011, a baby grand piano mysteriously appeared on a sandbar in the waters near Biscayne Bay in Miami, Florida. The sight of this piano in the middle of the water sparked viral discussions and theories about its origin. This event even captured the attention of national news outlets and coverage by CNN. It was finally revealed that a sixteen-year-old aspiring artist and high school student was responsible. His efforts were in hope of creating a surreal image of a "piano bar" for his application to Cooper Union in New York. His efforts went far above and beyond what the application needed, but he was willing to go the extra mile.

Your extra effort may not pan out the way you want. Admissions at Cooper Union said they didn't look at the student's application more favorably because of the piano event. Although his efforts may not have impressed admissions at Cooper Union, his efforts to stand out were appreciated by others. Don't let the failures that happen keep you from going above and beyond.

This notion doesn't have to be a grand display of effort. Simply spending more time in your studio than most, or spending money on a workshop or conference that will help your practice, is just as good. The idea behind this notion is simply to say that, to be ahead of the pack, you have to do something different, and that something different is something that others aren't willing to do.

YOUR GOOGLES

- Artist paints on Palestine wall
- Artist Tatyana Fazlalizadeh

- Artist Abraham Poincheval

HOMEWORK

Start analyzing and breaking down your creative practice and routine. How do they relate to your peers or to people you admire in the art world? How are they similar and how are they different?

Jot down some ideas of how you can start separating yourself from the pack by going above and beyond in your creative practice.

What extra effort can you start adding to applications and submission to stand out?

What creative activities can you add to your networking efforts?

EVALUATING PROJECTS

When starting a creative career, many of us will take any opportunity we can just to learn the ropes, network, gain experience, and get our work out there. Think of this phase as an internship. As growth occurs and work is refined, those same opportunities – even the well-compensated ones – start to become a roadblock to your development. The passion projects, the reason why you picked up a camera or a brush or a pen in the first place, are now on the back burner. Many full-time artists like myself have to find ways to create a balance between our passion projects that we love and commercial work for clients. There are three criteria that I review when considering a new project.

ARTISTIC GROWTH

Ask yourself, does the opportunity afford you room to grow? Sometimes, a project may come across your practice that is a repeat of work you have previously done, or is similar. I avoid many of these. You have to respect your time, which is precious, and spend it on projects that challenge your creativity and push your boundaries. Projects you accept should have a reasonable amount of creative freedom to experiment. Without that creative freedom, you've become a hired contractor for that project, rather than an artist creating.

ADEQUATE COMPENSATION

Ask yourself, is the compensation more than adequate? First, if you *didn't* take on a project, what else would you have been doing? Taking on projects requires time, resources, and energy that others need to acknowledge. The lack of adequate compensation belittles the work and effort. Requiring compensation forces others to value the work. Second, those projects that generously compensate your practice help support experimentation and passion projects that aren't commercial.

NEW OPPORTUNITIES

Ask yourself, does this opportunity widen your network? Sometimes projects may sound good but lack the opportunity to open up new doors for your practice. An example would be exhibiting in the same area multiple times, or in an area where there's no exposure to new markets, such as a project for a private client's home, where your work will only be seen by a few. Rather, you want to accept projects that expose you to new markets, experiences, curators, museums, galleries, organizations, and more because these projects tend to provide benefits that last long term.

NOTES 'N' DOODLE

"We tend to only take commissions that fit my passion projects and which can be steered to fit within the certain series I am a working on at the time. I don't take on projects or commissions that are outside my realm of what I do and who I am as an artist."

Greg "Craola" Simkins, artist

CLOSING ADVICE

BE EASY TO WORK WITH

I cannot tell you how many opportunities I have received due to the fact that I was easy to work with. Not that I was willing to compromise my vision, but that I was focused on being professional and reliable. That's what galleries, curators, collectors, sponsors, nonprofits, and art institutions want – an artist they can rely on to not only create great work, but to deliver work on time, to respond to emails, to send images when needed, and more. Whatever you need to do to deliver your work on time, do it. Whatever you need to purchase to complete and meet a deadline, buy it. Whatever is necessary to organize your practice, get it. As an artist, there are a million things working against you. Don't shoot yourself in the foot and make unforced errors.

INVEST IN YOURSELF

The most import thing you'll ever invest in is yourself. This is just a good life lesson in general, but we can always apply it to our practice. Travel to an art fair in a different state or country. Take a welding or a photography workshop. Go to a creative conference or upgrade your tools and materials. I am frequently using money that I receive through commission work to invest in buying new equipment such as laser cutters and professional paint sprayers. The result is that my practice's capabilities keep expanding. Take similar steps in educating yourself and acquiring new resources. You have to be the first to invest in your practice because if you don't, no one else will. Roll up your own sleeves. Communicate to others that you're putting in the effort, and they will be more likely to assist because they know you'll value any support you receive.

PUT IT OUT IN THE WORLD

Imagine driving down the road and you suddenly see a stalled car in the right lane blocking traffic. You look closer and see the driver of the car sitting in the driver's seat. You don't know what's happening so you drive past without stopping. Now, imagine you're driving down the road through traffic and you happen across a car in the right lane slowly moving. It's slowly moving because the driver is struggling to push the car off the road. Seeing this scene makes you want to pull your car to the side of the road and help the driver push the car, so you do just that.

You want to help push the car because it's human nature to help those who help themselves. As an artist, show others that you're putting in the work to accomplish a goal. Don't just ask for help without rolling up your own sleeves.

AS AN ARTIST, SHOW OTHERS THAT YOU'RE
PUTTING IN THE WORK TO ACCOMPLISH A GOAL.
DON'T JUST ASK FOR HELP WITHOUT
ROLLING UP YOUR OWN SLEEVES.

ADDED READING AND RESOURCES

"THE CAPACITY TO LEARN IS A GIFT;
THE ABILITY TO LEARN IS A SKILL;
THE WILLINGNESS TO LEARN IS A CHOICE."

BRIAN HERBERT

WEBSITES

NEW RESOURCES

Artguide.pro

Artnet.com

Artsy.net

ArtTactic.com

Behance.com

Google Arts and Culture

MoMA.org

Saatchiart.com

Saatchi.com

LEGAL AND PROFESSIONAL

Copyright.gov

Creativecommons.org

Itsartlaw.org

Legalzoom.com

Uspto.gov

EDUCATIONAL

Curious.com

Instructibles.com

Lynda.com

Teamtreehouse.com

Tutsplus.com

Udemy.com

ONLINE BLOGS AND MAGAZINES

99u.adobe.com

Aestheticamagazine.com

Artinamericamagazine.com

Artreview.com

Arttactic.com

Creativelive.com

Designboom.com

Digitalartsonline.co.uk

Hyperallergic.com

Ideo.com

Juxtapoz.com

YOUTUBE CHANNELS TO FOLLOW

Art21

The Art Assignment

CreativeMorningsHQ

Creative Time

The Futur

Gagosian

Guggenheim Museum

Montanacolorstv (Montana Colors)

Museum of Modern Art

San Francisco Museum of Modern Art

Smarthistory

Tate (Tate Modern Museum)

Whitney Museum of American Art

DOCUMENTARIES

Abstract: The Art of Design | Production: RadicalMedia and Tremolo

Ai Weiwei: Never Sorry | Director: Alison Klayman

A Ballerina's Tale | Director: Nelson George

Banksy Does New York | Director: Chris Moukarbel

Beltracchi: The Art of Forgery | Director: Arne Birkenstock

Bill Cunningham New York | Director: Richard Press

Blurred Lines: Inside the Art World | Director: Barry Avrich

Dior and I | Director: Frédéric Tcheng

Eames, the Architect and the Painter | Directors: Jason Cohn, Bill Jersey

Exit Through the Gift Shop | Director: Banksy

Fake or Fortune? | Production: BBC Productions

Floyd Norman: An Animated Life | Directors: Michael Fiore and Erik Sharkey

The Hand Behind the Mouse: The Ub Iwerks Story | Director: Leslie Iwerks

I Am Sun Mu | Director: Adam Sjöberg

Iris | Director: Albert Maysles

The Price of Everything | Director: Nathaniel Kahn

Saving Banksy | Director: Colin M. Day

She Makes Comics | Director: Marisa Stotter

Sky Ladder: The Art of Cai Guo-Qiang | Director: Kevin Macdonald

Waste Land | Directors: Lucy Walker, Karen Harley, João Jardim

The Wrecking Crew | Director: Denny Tedesco

Yarn | Directors: Una Lorenzen, Heather Millard, Thordur Jonsson

BOOKS

The $12 Million Stuffed Shark: The Curious Economics of Contemporary Art | Don Thompson

An Audience of One: Reclaiming Creativity for Its Own Sake | Srinivas Rao, Robin Dellabough

Art History: Its Use and Abuse | William McAllister-Johnson

Artificial Hells: Participatory Art and the Politics of Spectatorship | Claire Bishop

Art, Money, Success: Finally Make a Living Doing What You Love | Maria Brophy

Bad New Days: Art, Criticism, Emergency | Hal Foster

Big Magic: Creative Living Beyond Fear | Elizabeth Gilbert

Can't Hurt Me: Master Your Mind and Defy the Odds | David Goggins

Color | Betty Edwards

Contagious: Why Things Catch On | Jonah Berger

Creative Block: Get Unstuck, Discover New Ideas. Advice and Projects from 50 Successful Artists | Danielle Krysa

Creative Confidence: Unleashing the Creative Potential Within Us All | Tom Kelley, David Kelley

The Creative Habit: Learn It and Use It for Life | Twyla Tharp

Don't Panic: A Legal Guide (in plain English) for Small Businesses and Creative Professionals | Art Neill, Teri Karobonik

Drawing on the Right Side of the Brain | Betty Edwards

EyeMinded: Living and Writing Contemporary Art | Kellie Jones

Frida: A Biography of Frida Kahlo | Hayden Herrera

Never Split the Difference: Negotiating as if Your Life Depended on It | Chris Voss

On Writing: A Memoir of the Craft | Stephen King

The Power of Habit: Why We Do What We Do in Life and Business | Charles Duhigg

Purple Cow: Transform Your Business by Being Remarkable | Seth Godin

Real Artists Don't Starve: Timeless Strategies for Thriving in the New Creative Age | Jeff Goins

Sell Your Art Online: Live a Successful Creative Life on Your Own Terms | Cory Huff

Sponsorship: the Fine Art of Corporate Sponsorship, the Corporate Sponsorship of Fine Art | Ryan McGinness

Steal Like an Artist: 10 Things Nobody Told You About Being Creative | Austin Kleon

*The Subtle Art of Not Giving a F*ck: A Counterintuitive Approach to Living a Good Life* | Mark Manson

BOOKS CONTINUED

The Tipping Point: How Little Things Can Make a Big Difference | Malcolm Gladwell

Tribes: We Need You to Lead Us | Seth Godin

The War of Art: Break Through the Blocks and Win Your Inner Creative Battles | Steven Pressfield, Shawn Coyne

The Writing Life | Annie Dillard

Your Inner Critic is a Big Jerk: And Other Truths About Being Creative | Danielle Krysa

PODCASTS

99% Invisible

Art Biz Podcast

ArtCurious

The Artist Next Level

Artists Helping Artists

Art + Music + Technology

Artsy

ArtTactic

Bad at Sports

Bench Talk

Beyond the Studio

Creative Caffeine

Creative Pep Talk

Dr. Janina Ramirez – Art Detective

Harsh Truth with Matt Gondek

How I Built This: "Radio Lab"

Hyperallergic's Art Movements Interviews by Brainard Carey

The Jealous Curator

The Modern Art Notes Podcast

Raw Material

Revisionist History

Savvy Painter

A Small Voice

Song Exploder

Sound and Vision by Brian Alfred

TED Podcasts

The Thriving Artist

Vantage Point Radio

ESSAYS AND PAPERS

"Curatorial Toolkit: A Practical Guide for Curators" | Karen Love

"Doctor, Lawyer, Indian Chief: 'Primitivism' in 20th Century Art' at the Museum of Modern Art in 1984" | Thomas McEvilley

"Why Have There Been No Great Women Artists?" | Linda Nochlin

"Please Wait by the Coatroom: Wilfredo Lam in the Museum of Modern Art" | John Yau

Thank You

First and foremost, thank you for taking time to read this book – and I would like to congratulate you on taking the first steps in investing in your own career. This book was born out of my constant desire to help others. I wanted to be the artist I wanted to meet when I first started out. As my art career grew, I was constantly being asked questions about exposure, pricing, galleries, relationship-building, street art, copyrights, and everything else under the sun. Eventually, I created an Instagram post called "Art Tip Tuesday," where I would share information I find valuable and insightful with artists around the world. Over the years, this effort showed me that there is a need for a resource that artists can carry with them in and out of the studio... a resource that they can write in and make their own. I hope anyone reading this book will be find some useful help to tackle not only art, but life in general.

This book would not be possible without the love and encouragement of my family and friends, especially my mother. Without her, this would not be possible. She is the person you all have to thank for this book. There are so many other people and organizations that have been involved in helping me grow as an artist. There aren't enough pages in the world to write them all down, but I'll try.

OREN B. LOMENA | ADAM GORDON | POL CORONA | RAMIRO ESTRADA | ANDREA HUNT | MARY VALDEZ | REDLINE | CASEY KARNS, BIRDCAP | GREG "CRAOLA" SIMKINS | JUSTIN BUA | ANTOINE GIRARD | LUIS VALLE | JAIME MOLINA (CUTTYUP) | JON AND LINDSEY LAMB | JADE ZUBERI | JAI HARRIS | JUAN "JOON" ALVARADO | GROW LOVE | FELIX FAST4WARD, VENUS CRUZ | DAMIEN HINES | CARL CARRELL, JOHN GRANT | PICHIAVO | BECKY WAREING STEELE | SANDRA FETTINGIS | CHRIS ROTH | DOUG KACENA | LOUISE MARTORANO | RONALD JACKSON | PETER MILLER | DR. FAHAMU PECOU | ROB HILL | THEASTER GATES | PANAL 361 | ROBIN MUNRO | JOLT | TINZ | KAREN ROEHL | SUCHITRA MATTAI | ANDREW HUFFMAN | ANTHONY GARCIA | PATRICK MCGREGOR | JASON GARCIA | KIRI LEIGH JONES | BE A GOOD PERSON | PJ D'AMICO | DYLAN SCHOLINSKI | MARK SINK | DAISY PATTON | COLLIN PARSON | ELLA MARIA RAY | ESTHER HERNANDEZ | JOHN LAKE | MOLLY BOUNDS | STEPHANIE KANTOR | SAMMY LEE | ASHLEY FRAZIER | TYA ALISA ANTHONY | PAUL HAMILTON | DJ CAVEM | CALEB HAHNE | MICHAEL SPERANDEO | CLAY HAWKLEY | MACKENZIE BROWNING | AMA ARTHUR-ASMAH | ARTWORK ARCHIVE | DJAMILA RICCIARDI | ROBIN ALLI GALLITE | PANAMA SOWETO | SPENSER BERNARD | EMAN ISMAEL | PETER LUIS | PAT MILBURY | KEITH & WISER | THEY SHOOTN | MATT MCDONALD | MUSA BAILEY | CORI ANDERSON | ALL MY COLLECTORS | LA NAPOULE ART FOUNDATION | BBOY FACTORY | SCHOOL OF BREAKING | SONGAR | JUSTIN ANTHONY | CHRISTINE SWEREDOSKI | THE FLUELLEN BROTHERS | THE JOHNSON SISTERS | GEORGE & ESOHE GALBREATH | JOY ARMSTRONG | FELIX AYODELE | JUSTIN GREEN | SEAN CHOI | DENVER ART MUSEUM

About the Author

THOMAS "DETOUR" EVANS IS A PROFESSIONAL AMERICAN
ARTIST. BORN INTO A MILITARY FAMILY, DETOUR SPENT HIS
YOUTH TRAVELING THE WORLD, EVENTUALLY SETTLING
IN COLORADO, WHERE HE ATTENDED THE UNIVERSITY OF
COLORADO. WHILE HE INITIALLY STUDIED BUSINESS,
HIS PASSION WAS ART. INITIALLY WORKING OUT OF
HIS KITCHEN, CREATING ART FOR HIMSELF, DETOUR
HAS TRANSITIONED TO FULL-TIME VISUAL ARTIST,
CREATING ARTWORK FOR MAJOR BRANDS AND LARGE
CORPORATIONS. HE NOW SPENDS HIS DAYS CARVING OUT
NEW AND ALTERNATIVE PATHS IN THE ART WORLD AND
SHARING HIS INSIGHTS ON HIS POPULAR INSTAGRAM
ACCOUNT @DETOUR303.